The Warsaw Ghetto

The Warsaw

GHETTO

A Photographic Record 1941-1944

JOE J. HEYDECKER

Foreword by Heinrich Böll

I. B. Tauris & Co Ltd *Publishers* London

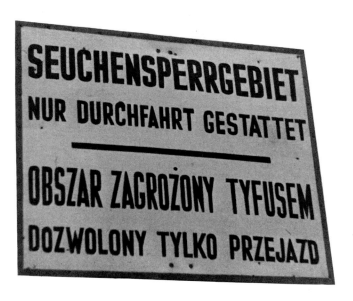

Published by

I.B. Tauris & Co Ltd
110 Gloucester Avenue
London NW1 8JA

This edition © 1990 I.B. Tauris & Co Ltd

© 1981 Atlantis Livros Ltd, São Paulo, Brazil (three language edition)
© 1983 Deutscher Taschenbuch Verlag, Munich

British Library Cataloguing in Publication Data

Heydecker, Joe J
 The Warsaw Ghetto: a photographic record, 1941–1944.
 1. Poland. Jews. Social conditions, history
 I. Title II. Warschauer Ghetto. English
 305.8'924'0438

 ISBN 1-85043-155-8

Printed and bound in Great Britain by
Butler & Tanner Ltd, Frome and London

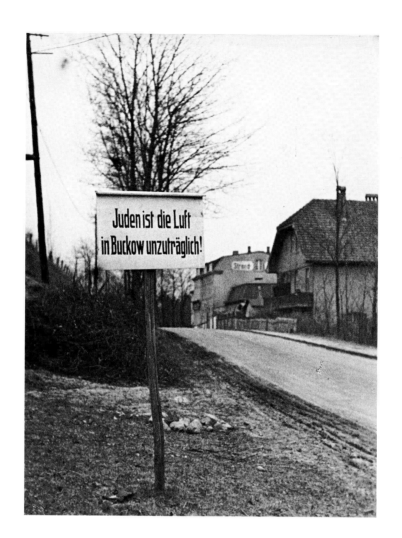

CONTENTS

A fter countless publications, films and lectures on the subject, a new account of the Warsaw ghetto and uprising might seem unnecessary. But Joe J. Heydecker smuggled himself into the ghetto, before and after the uprising, at considerable risk to his life. It is a disgrace that his photographs and his account of events had to wait so long to be published in West Germany, a disgrace that it should have been in Brazil that they were first published by a group of South American Jews.

It might also seem odd that in Germany, the land of luxury editions and lavishly illustrated tomes, this book was so slow to find a publisher. For its authentic photographs of the Warsaw ghetto are introduced by an eye-witness who was neither culprit nor victim, 'merely' a soldier in the German army — even if without the army neither the creation of the ghetto nor the running of the concentration camps would have been possible.

However Heydecker, famed and respected for his book on the Nuremberg trials, furnishes in his commentary sufficient proof that people guessed what was going on, and that the army knew. He cites not only the evidence of German eye-witnesses who took no part in what happened, but also an army field order issued on 10 October 1941 by Reichenau, who evidently felt obliged to react to the unrest — reflecting both approval and condemnation — among his troops. In this order Reichenau described 'the extermination of Asiatic influences on European culture' as 'the essential purpose of the campaign against the Jewish-Bolshevik system', adding: 'There is consequently a job to be done which is outside the scope of simple military duties ... Therefore the soldier must fully appreciate the necessity for the tough but justified sanctions against the sub-human Jews.'

Heydecker cites another army field order, issued by Rundstedt in September 1941, which seems to refer to German soldiers who had witnessed certain events or possibly even taken part in them: 'Unauthorized action or participation by German soldiers in the excesses of the Ukrainian population against the Jews is forbidden, as are observation or taking photographs of special commandos in the execution of their orders.'

Where are these eye-witnesses, where are their photographs? Are they perhaps passed around, secretively, sneeringly, when old comrades of war get together? Heydecker's photographs of the Warsaw ghetto, together with his eyewitness account, his description of what he saw, have a certain rarity value. In one year 10 per cent of the ghetto population, 44,630 people, died of starvation and typhoid fever, and on 16 May 1943 SS-Obergruppenführer Jürgen Stroop reported: 'The former

Jewish Quarter of Warsaw no longer exists. According to our *evidence* [my emphasis], the total number of Jews seized and terminated is 50,065.' My God, where would a high-ranking murderer be without his *evidence*!

Heinrich Böll

Adapted from an article in DIE ZEIT, 28 January 1983.
* This side of the war has been adequately documented by Martin Broszat, Hans-Adolf Jacobsen and Helmut Krausnick in ANATOMIE DES SS-STAATES

16 October 1940–16 May 1943

T he district which the German Governor of Warsaw, Ludwig
Fischer, declared the Jewish Quarter in mid-October 1940,
had, in normal times, been home to some 160,000 people.
Because of the war its population had risen to 320,000,
made up of 80,000 Poles and 240,000 Jews, who had long
lived there or who had sought refuge from the surrounding provinces.
Another 160,000 Jews were scattered in other parts of the city. Fischer's
decree of 16 October 1940 required them to move into this Jewish
Quarter. The same decree required any Poles residing there to move out.
This order had to be carried out within 14 days, and during those two
weeks the population of this restricted area swelled to almost 400,000.

This enormous transfer of people took place under the most desperate
conditions. It was impossible in such a short time for 160,000 people to
move all their furniture and effects and the tools and equipment they
needed for their livelihood. The Jews, who since mid-November 1939
had been obliged, on the orders of Governor Hans Frank, to wear a
white band with a blue star of David on their right arms, moved their
vital personal effects — along with the sick, the dying, infants and the
disabled — by handcart, pram or anything else they could knock
together, into the area designated to them. Most of their possessions —
furniture, machines, tools and workshops — had simply to be
abandoned. More desperate than this enforced tearing up of roots was
the hopeless quest for shelter in the already over-filled quarter. Anyone
with money or other valuables might have been able to buy a place, but
the vast majority of these Jews were working-class people, tradesmen,
labourers, people of slender means. They wandered through streets and
alleys pushing and pulling their pitiful barrows, carrying their miserable
bundles and boxes, until they sank exhausted in some corner or on the
kerbside and could go no further. This went on for weeks — for many of
the less fortunate for months — till they had some sort of a roof over
their heads, enough space to lie down on the floor of an already
overcrowded room, a corner of a landing, a cellar in a demolished
house, a cubby hole under a stairway. For many death itself solved the
problem.

On 15 November, fourteen days after this procession, the German
police, together with Polish city police mobilized for the occasion,
barricaded the access roads to the ghetto and sealed it off. The people
thus crammed together found themselves trapped. Barbed wire and,
later, high wooden fences completed their incarceration. Soon
afterwards, by German command, a brick wall was built around the
whole area, 16 km long, 3 m high, the thickness of a brick. This was
completed in the summer of 1941. But long stretches of it, especially
across the side roads that led into the broad Marszalkowska Street, one

of the busiest and most fashionable streets of the city, were finished much earlier.

The ostensible reason for this isolation, according to the Germans, was the danger of infectious disease. Large warning notices in German and Polish were posted at the entrances to the area. In fact the situation was exactly the reverse. As a consequence of the isolation, overcrowding, unparalleled food shortages and inhuman sanitary conditions, typhoid fever broke out in the ghetto. In addition, more and more people were compelled to go there. In the western provinces of Poland Jews were obliged to abandon their work and their homes and move into the ghettos created by the authorities in the major cities. And so a constant stream of people flowed into the Warsaw ghetto from the surrounding provinces, and later also from other occupied European countries and even from Germany itself. Eventually, every building would house an average of 393 people, each room would be home to about 13. In May 1941 the population of the Warsaw ghetto stood at 430,000, but by September of the same year, it had fallen to 404,000.

These figures testify to the constant presence of death. Though typhoid fever was a constant risk — in December 1941, for example, 2405 cases were officially registered — most died quite simply from starvation. At this time Germans in Warsaw were receiving daily a ration of 2310 calories; the daily ration of those in the ghetto in the second half of 1941 was only 184 calories. At this time the official ration for Jews was: 1 kilo of bread a week and 250 g of sugar, 100 g of jam and 50 g of fat a month. The bread was adulterated with potato peel and sawdust. Even this starvation diet was irregularly distributed. Bernard Goldstein reports in his recollections of the ghetto: 'Though the ration cards entitled them to more, each person in fact got about 20 g of bread and some coarse flour each day, and occasionally a little sugar.' More than 100,000 people lived entirely on a watery soup that was distributed every day by a Jewish self-help organization. Frequently it was, in fact, no more than boiled hay. In February 1941, 1025 people died in the Warsaw ghetto; in March, 1608; in April, 2061; and in May, 3821. In the whole of 1941, 44,630 people, more than 10 per cent of the ghetto's population, died, mostly from hunger, 15,780 from typhoid fever and an unknown number from cold and exposure during the winter months. Governor Fischer cynically observed: 'Hunger and privation will deal with the Jews, and the Jewish question will resolve itself in the cemetery.'

A report issued by the Polish underground press in April 1942 states: 'Daily we see pitiful hunger-inflated bodies; we see children, reduced to skeletons and covered in sores from starvation, lying in the streets, their strength gone. There is only one thing left for them: to die in the street.' Bernard Mark reports: 'Starvation caused mass begging. Famished children sang with pleading voices the well-known ghetto song: "Gite mentschn, hot rachmunes, der tate is geschtorbn fun hunger un nojt. Gite mentschn, hot rachmunes, warft arop a schtikele brojt" (Good people have pity, our father has died of starvation. Good people, have pity, throw us a crust).'

The following piece was found when the Ringelblum Archives were uncovered in the ruins of the ghetto after the war:

A life without bread, without a spoonful of hot food over a period of years, has a terrible, shattering effect on the soul. Many of the exhausted, famished people became helplessly apathetic. They lay down where they could, stayed there until they no longer had strength enough to get up again. In houses along Krochmalna, Ostrowski, Smocza and Niska streets exhausted people lay all day wherever space could be found. Among them were whole families of ten or twelve people. They lay there motionless with pale faces and burning eyes, one next to the other, swallowing their saliva. Their exhaustion left them insensible. All were filled with just one crazy desire, one hopeless dream: to find a piece of bread.

The ghetto administration, the German-appointed Jewish Council, was helpless, powerless to do anything. The two main ghetto problems — starvation and lack of space — were insoluble. A Jewish police force, up to 3800 strong — its members frequently baptized Jews, or former members of the Polish armed or police forces, often minions — in blue uniforms and armed with rubber truncheons, kept order at the beginning, and later played into the hands of the German death-commandos, no doubt under the crazed illusion that they might save their own skins. In addition there was a special Jewish police force, the so-called 'Thirteeners', who collaborated closely with the Gestapo. Officially they were supposed to investigate cases of corruption but of course their whole hierarchy was itself corrupt from top to bottom. The main profiteers, who made millions in shady deals in forged documents, privileges and other objects of value, were Gestapo officials, members of the SS and SD and other German government officials who were in some way involved with the ghetto. Their opposite numbers on the Jewish side of the wall were made up of a tiny minority who in spite of the appalling conditions were still able to live a life of luxury. However, some goods did find their way into the ghetto through such channels and kept some alive a little longer.

In fact, in spite of rigorous segregation, the ghetto was never without some outside contact. At first there was even a postal service, and for a time Jewish aid organizations in the United States were permitted to send parcels. When these two sources were shut off — the Germans closed the post office and Hitler's declaration of war on the United States stopped the flow of charity from there — it was left to the smugglers to get their wares into the ghetto by ingenious means, over and under the wall, through the sewers and in coffins. But this could never be remotely sufficient to keep alive nearly half a million people. A report printed by an illegal Jewish newspaper reads: '50 per cent of the people are literally dying of hunger, 30 per cent are hungry as a matter of course, 15 per cent eat occasionally.'

In spite of this, according to the findings of a committee of Jewish doctors, it would have taken five years for everybody in the ghetto to starve to death. In the meantime the Germans had decided to bring about the final solution in a different way. War against the Soviet Union had begun and behind the front special units had began the mass execution of Russian Jewry. In the second half of 1941 they introduced the gas chambers, a method previously used in Germany itself to kill the

mentally sick. On the Eastern front they first used mobile gas containers mounted on trucks, but those responsible for the final solution saw that their capacity was too limited. Thus gas chambers were installed in special concentration camps with a daily murder capacity of many thousands.

The great liquidation suffered by the Warsaw ghetto lasted from 22 July to 13 September 1942. It was preceded by terrorist action, shootings in the streets and the taking of hostages from the Jewish community. From 22 July the Jewish Council and its police were under orders to bring 6000 'useless' Jews every day to what was called the 'Assembly Point', a level-crossing over Stawki Street, for 'resettlement in the East'. From there they were packed into railway cattle wagons and taken direct to the gas chambers of Treblinka.

Though news had got through to the Warsaw ghetto of the mass murder of Russian Jews and of the liquidation of ghettos in smaller provincial centres, few were in fact suspicious. Many believed the German statement, relayed by the Jewish Council, that 60,000 workers were needed for important construction work near Minsk. But all the signs spoke against this. The first to be herded together and taken away were the beggars, the sick, prisoners and 200 children from the Jewish orphanage — such people as could be of no possible use to the Germans as workers. In the case of the physically handicapped even pretence was dispensed with. They were taken to the ghetto cemetery and shot on the edge of a mass grave. Then it was soon observed from the numbers on the side of the railway wagons that they returned remarkably quickly to collect new cargo, too quickly indeed to have made the long journey so far east. Through Polish railway workers precise descriptions of what was happening at Treblinka and even photographs of the death camps, found their way into Warsaw. A Jewish resistance group proclaimed:

> Jews! You are being deceived! Do not believe you are to be deported for work and nothing else! You are being sent to death! This is the continuation of the Satanic campaign of destruction already carried out in the provinces. Do not let yourselves be carried off to death of your own free will! Resist! Fight tooth and nail! Don't go to the Assembly Point! Fight for your lives!

The chairman of the Jewish Council, Adam Czerniakow, committed suicide so as to release himself from a tormented conscience on the second day of the campaign. Eight members of the Jewish police did the same, no longer to be lackeys of the Germans. Of course this had no effect on the Germans' campaign of murder whatsoever. The transportation of Jews continued until even the most naïve knew full well that the destination was not a work-camp in the East but death itself. The SS, the Jewish police, the auxiliary militia from Lithuania combed all parts of the ghetto to get the daily quota together and herded their captives to the Assembly Point. Barricaded front doors were hacked down, women and children torn away. The eye-witness Bernard Goldstein reports: 'Children clung to fathers, wives to their husbands. They clung to bits of furniture, a doorpost, anything they could get hold

of to save themselves from being carried off by the police. The noise of this gruesome hunt could be heard all day long.'

At first you were to some extent protected from deportation if your work card said that you were employed in a factory essential to the war effort. Consequently a wild, desperate hunt for such cards, genuine or false, began. Then, as it became more and more difficult for the Germans to get the daily quota together, these lost their value. Anyone who could not stay hidden was in danger of being picked up at any moment in the streets and taken to the Assembly Point. Later, all the workers in every factory had to appear together and file past an SS man who with his cane indicated who was to go left and who right. Those on the right were marched off to the Assembly Point and to their death.

Very soon the words 'Assembly Point' became invested with gruesome overtones. The Germans' original claim that 60,000 people were to be resettled was soon shown to be mere fabrication. Those who hoped they would be left in peace if they managed not to be included in the 60,000 got caught up in the cogs of the German death-machine just the same. The man-hunt went on. The number exceeded first 100,000 and then 200,000. No end was in sight. We have accounts of those awful days in the Warsaw ghetto that the mind simply cannot grasp. The victims were herded like cattle, their way to the Assembly Point punctuated with beatings and whippings. Anyone who screamed or caused any inconvenience to the murderers could reckon on being gunned down on the spot. Children were torn from their mothers, families were split, pleas for mercy and tears were answered with disdain.

The result of all this speaks for itself. At the beginning of October 1942, SS Obergruppenführer Jürgen Stroop reported to Police Chief Friederich Krüger that altogether 310,332 inhabitants of the ghetto had been 'resettled'. But this figure covers only those who had been counted on their way to Treblinka by the SS. Those who were slaughtered during the ten-week period in their homes and on the streets were not counted. At the finish, the survivors, between 65,000 and 70,000 Jews, were squeezed together into the so-called 'Little Ghetto', an area 950 m by 280 m in the north-east corner of the old ghetto. They were the chosen ones who — for the moment — seemed to the Germans to be indispensable for work in the factories in the area. Goldstein, whose escape soon after this campaign of murder took him through the ghetto, puts the whole event in one horrifying picture: 'Slowly we went through the deserted streets. A terrifying silence gaped through the empty windows and doors. These streets had once been teeming with life, even if wretched, despairing and oppressed. But what had become of those who had crowded into the now empty buildings and abandoned yards? They had been gobbled up at the Assembly Point, like so much fodder, by the insatiable German death-machine.'

Himmler's order to liquidate every remnant of the ghetto restarted the deportation of Jews to Treblinka. Once more the factories and workshops were combed for workers who could be dispensed with. Then, suddenly, on 18 January 1943, a group on their way to the Assembly Point put up a fight. A few Jews produced pistols and fired on

their SS escorts. The group disappeared before the Germans could recover from the shock. Now it was clear that these last survivors in the ghetto had somehow armed themselves and would no longer be led like lambs to the slaughter. On 19 April 1943, when Stroop attempted to penetrate the Little Ghetto with three pieces of artillery and three tanks to carry out Himmler's liquidation order, he encountered such stubborn resistance that he had to withdraw. The heroic uprising of the Warsaw ghetto had begun.

It lasted nearly a month, until 6 May 1943. During those four weeks the Germans had to fight for every house and every street. They had to bring in artillery, tanks and flame-throwers, engineers with explosives, more than 2000 SS soldiers, German policemen, army personnel as well as Polish and Lithuanian allies, before the Jewish resistance was crushed. The Jews, men and women together, fought with Polish and home-made hand grenades, with pistols and other fire-arms of German, Polish or Italian origin. The whole area was honeycombed with subterranean bunkers that served as sleeping quarters, hospital wards, stores and refuges for the aged, the children and those physically unable to fight who had in some way survived the liquidation. They fought the Germans fiercely; they drew pistols even as they were taken captive and told their executioners in no uncertain terms that this wickedness would be avenged.

The Germans, on the other hand, found easier ways of exterminating the last man, woman, the aged, the pregnant and the children. They dynamited houses or set fire to them. For four weeks there lay over the whole ghetto area a black cloud of smoke by day and the dark red glow of fire by night. On 25 April, Stroop telexed his superiors in Cracow: 'If last night what was the ghetto was alight and burning, tonight it is one mighty furnace.' Yet in a later telex he had to admit: 'Repeatedly we saw that Jews and bandits preferred to go back into the fire than to fall into our hands.' Proudly he announced on 16 May: 'The former Jewish Quarter of Warsaw no longer exists. According to our evidence, the total number of Jews seized and terminated is 50,065.'

Those the Germans took alive were either shot then and there or sent as speedily as possible to Treblinka. The number of those who lost their lives when their houses were blown up or burned down, or who were buried in bunkers or drowned or suffocated in sewers will never be known. Though German demolition units later resumed the destruction and tried to raze the entire area to the ground, when the Red Army occupied Warsaw in January 1945, a handful of Jews were discovered still holding out in some of the subterranean bunkers. They and a few fortunate individuals who had succeeded in escaping from being gassed in Treblinka were all that remained of the more than half a million who had once inhabited the Warsaw ghetto.

I was born on 13 February 1916 in Nuremberg. From January 1931 to July 1933, I was an apprentice photographer under Stefan Rosenbauer (who later emigrated to Rio de Janeiro) in Frankfurt am Main. Uncomfortable at the situation, my parents left Germany at the beginning of 1933, though they were in no danger racially or politically. I can still hear my father's words: 'I can't carry on living in a country like this'. I mention this because it throws some light on my personal background. Under my parental roof there had always been a liberal atmosphere. Among the wide circle of my father's friends there were no religious or racial prejudices. They watched with growing anxiety the rise of Hitler, his military, anti-Semitic and anti-democratic propaganda, the SA gangs and street fighting. For my mother's anxiety there was a personal reason: one of her children by a previous union, my half-brother, Alwin had a Jewish father, and later came within the compass of the Nuremberg racial laws. It should be mentioned in passing that in August 1939, just as the war was beginning, he was able to get out of Germany and find his way to Brazil by way of Switzerland.

A novel I wrote in January 1933 disappeared soon after February along with its unfortunate publisher. In the middle of 1933 I received permission from my parents to break off my apprenticeship prematurely and to go abroad. I lived in Meggen near Lucerne, in Switzerland, but was able to travel a lot, staying for various periods in Czechoslovakia, Austria, Hungary and Yugoslavia. I published occasional articles in German-language newspapers in Lucerne and Prague. I did no work for newspapers in Germany. In 1937 I spent almost the whole year in Poland. My main occupation was in my parents' business, organizing screenings in various countries of a film called 'Pope Pius XI Speaks to You'.

In 1937, in connection with this, I travelled all over Poland, particularly in Galicia and Volhynia, two districts with strong Jewish populations. My father and I, though easily recognizable as German Germans, were frequently the guests of Jewish families, and I remember with gratitude and nostalgia the warmth with which they received us. Here my thoughts go to the family of Benjamin Bruehl in Dubno, Zygmund Licht in Sambor and to the Fleiszer family in Rzeszów. In Warsaw I spent some of the happiest weeks of my life.

My life away from Germany markedly influenced my development as a young man. I was able to move about in a world that was then still free, among people of various nationalities, races and ways of looking at life. I was able to read books, journals and papers and assimilate information no longer available in Germany after 1933. I saw Germany

— or rather, Nazi Germany — as it really was. This not only immunized me to its temptations, it made me stand against them.

In 1938 I was in Vienna when the German army marched in. My passport had expired and the frequent deferment of my military service was brought to an end. I was called up in Vienna, returned to Berlin and worked in my parents' firm — they had also been obliged to return to Germany.

On 27 August I was ordered to report for duty the next day. Training took place for the Third Transport Division at Rathenow. From November 1939 till mid-December 1940, I was with Sapper Company no. 627 (Army post code 09216). Service in France followed. On 15 December, because of my photographic training, I was transferred to the Propaganda Training and Replacement Centre in Potsdam. At the beginning of 1941 I was ordered to Warsaw to join Propaganda Company no 689 (Army post code 21022) as a photo-laboratory technician. This was how I came to the city again.

Here I should mention two comrades, Köhler and Krause, both photo-laboratory technicians in my company. We were close friends, and it was with their help and co-operation that the negatives of the films used in my camera were secretly developed in the company's darkroom, kept hidden and later smuggled out. This makes it unnecessary to say anything about the political attitudes of our small group. My then wife, Marianne Heydecker (who died in 1968), was due for civil service and volunteered to serve in Warsaw in order to be near me. At the risk of her life — the house was searched by the Gestapo for various reasons which I will not go into now — she took care of the films till the war was over.

In September or October I was recalled from Russia, where the company to which I belonged was stationed near Roslawl, and posted to Potsdam, where I was given clerical duties with the replacement section until 11 August 1944. Then I was posted to a People's Grenadier Division, Tank Destroyer Unit 337 (Army post code 25361) in Piaseczno on the Vistula, not far from Warsaw. From 5 January 1945 I was in the military hospital at Beelitz near Berlin; I was discharged as the Soviet Forces drew closer on 22 April, then fled westwards. On 1 May I was 'overrolled' by the Americans at Vellahn on the Elbe, while hiding in a water main. From there I was able to find my way to my wife at Bad Liebenstein in Thuringia. She still had the negatives.

One day my wife and I showed them to Captain Kilbourn of the American Occupation Forces, Bad Liebenstein. He realized that they should be put in a place of safety and gave us exceptional permission to leave Thuringia and go to Bavaria a few days before the alteration of the demarcation of the Occupation Zones in the Russians' favour. Thus it was that the films arrived in Munich. There they came to the attention of the Officer then responsible for Radio Munich, Field Horine, who asked me to speak on the radio about the Warsaw ghetto. This I did on 4 November 1945. As far as I know this was the first eye-witness account given by a German.

A few days later I was sent by Horine to Nuremberg as a radio reporter.

There, on 20 November, began the trial of the most important war criminals, which I covered until it finished.* The following years were spent in journalistic and literary activities. Towards the end of 1960 my family and I moved to Brazil.

That is where the negatives are today. Most of them have been enlarged for the first time for this book, a task undertaken by my wife Charlotte Heydecker in her photographic laboratory in São Paulo. When they were taken in 1941 she was still a child. Now she watched, in the solitude of her darkroom, as the past was once again brought forth from the developing dishes into the present. We have a daughter who was then nine years old; for the first time my wife saw poor, wretched little children on the streets of the Warsaw ghetto whom we must all have on our conscience, and she told me — and I am not ashamed to admit this — that she wept as she worked.

I find it hard to explain why nearly forty years have passed before I have felt able to publish these pictures. I believe I simply did not have strength enough to write these words, though I did try several times. I still feel unable to do so. But now I must do what I can to set down what is seared into my memory, imperfect as it is, because time will run out.

*See my book THE NUREMBERG TRIAL.

February and March 1941

When I arrived in Warsaw at the beginning of January 1941, a despairing serving soldier, there was snow on the ruins and slush in the streets. German artillery and bombing had reduced the lively metropolis of pre-war days to a vast heap of rubble. I saw for the first time what was later to become a common sight in Europe: a broken and destroyed city, single walls still standing, traces of upper storeys, shattered windows, a bleak and empty sea of rubble. The people looked grey and hopeless. The uniforms of the German army and other units had changed the familiar streets even more out of recognition. Around the buildings in which the Occupation personnel were accommodated were crowds of freezing, begging children. Over and over again they repeated monotonously the one German sentence they knew: 'Bitte, Herr, ein Stückchen Brot' (Please, sir, a crust of bread).

Army responsibilities in my new unit — we were quartered in a school in Wolska Street — left me plenty of spare time. What had happened to the friends and acquaintances with whom I had so often passed the time in 1937? I found none of them. In fact I was rather glad of that. How could I, as a German soldier, show myself? Nevertheless, after a while I decided I would like to get in contact with Marguitta Olsiańska. Strange as it may seem today, the residents' registration office was still functioning. They gave me the address 'Ulica Dzielna 27 m 7'. On the next free evening I hired a horse-drawn cab and gave the name of the street to the driver. He drove on, and we finally arrived at one of the entrances to the ghetto. I was in uniform and my driver obviously thought nothing was amiss. Shocked, I had the man stop as I did not want to get mixed up with the guards. The driver explained that Dzielna Street was in the ghetto.

From that moment I was directly faced with the problem which had in fact been on my mind since the earliest days of my return to the city.

In January 1941 the ghetto was still new. The surrounding wall had only just been built and in many places was still unfinished. The few access roads had barbed wire across them and they were patrolled by German and Polish police. A tram service went through a narrow corridor of the ghetto but stopped nowhere. The curious often took rides on it to see what was going on behind the wall. Others stood around the ghetto entrances daily. They could see how those who had to go in and out were searched and beaten up by the police. At that time ghetto residents, individually or in groups, could still go to wherever they were employed outside the ghetto. When they came back there were frequently inhuman scenes. I spoke of this in my radio report. For instance, children who were trying to smuggle a loaf of bread back in

the ghetto were gunned down. Men, even the very elderly, were beaten till they bled. This manhandling was often encouraged by the crowd of hostile bystanders.

The bystanders. They were soldiers of every rank, officers too, often German civilians in government service, secretaries, uniformed officials, railway personnel, even sisters from the Red Cross. I believe I saw there the uniforms of every kind of unit and organization. Most of them stood rooted to the spot, speechless, and with blank expressions, watching those going in and out, the 'formalities' and the attendant brutality.

Some turned away, some gave encouragement. But most just stood there without revealing their thoughts and feelings. What is there to be said? Only this: we all saw, and knew, what happened. What happened at the gates of the Warsaw ghetto between 1941 and 1943 was seen by hundreds of thousands and probably many more. Certainly by almost everyone whose fate it was to pass through Warsaw during the war, and that was millions.

During this time, the Warsaw ghetto was filling to bursting point; more and more unfortunate people from the west provinces of Poland and other districts were crammed behind those walls. The Jews that were driven from their homes came in convoys of wretchedness. Each of their carts was pulled by one or two horses. Packed tightly with their pitiful belongings, women, children and the sick, they slowly made their way through the cold. Every day from early morning till late at night the wagons creaked through the snow towards the city. They passed the Wolska school where our company was quartered. From the roof of this building late one day in January I took the first photographs of this Jewish tragedy. Some days later, in spite of the protection of a German uniform and worried that I might be caught and have to answer questions, I took more photographs at the entrances to the ghetto.

One would be fully justified in asking after my motives. It must be said that at no time did I take photographs as part of my official duties in any propaganda company. I was not a reporter, I was a laboratory technician. My photographic activities were my own, carried out at my own risk. I was under no orders and, fortunately, my superiors knew nothing of my activities. I don't think I am capable of describing my own innermost being at this time. I was torn by shame, hate and helplessness. I had a burning wish for a quick and thorough defeat of Germany and yet could see that that would be a long time coming. My photographs were taken that this disgrace should not be forgotten, to keep alive the screams I wanted the world to hear. More than that I cannot say.

I am guilty: I stood there and took photographs instead of doing something. Even then I was aware of this terrible dilemma. To ask what I could have done then is a coward's question. Something. Kill one of the guards with my bayonet. Raise my rifle against an officer. Desert and go over to the other side. Refuse service. Sabotage. Refuse to obey orders. Give my life. Today I feel there is no excuse.

On 25 June 1941, a few days after the Russian campaign had begun, our company was in action clearing a wood near Rozana in Volhynia. We

lost one man and took some prisoners. Three of them were wounded and were unable to walk. They lay in a clearing where our group mustered. It would have been possible to make stretchers from branches and carry them away. As a matter of course, we began to do so, but our commanding officer, Oberleutnant Thürmer, said: 'Don't be ridiculous, deal with them now'. We stood in a sort of semi-circle round the clearing. He looked us over first one than the next. His eye passed over me to the next. He picked out two members of the company and ordered them to shoot the three wounded men. We marched off with the prisoners who were not wounded. I saw my comrades take aim at the three who lay there on the grass. I heard the shots. Mission accomplished. I can still hear them, and still the question tortures me: what would I have done if my commander's eye had rested on me and the order had come? It passed me over. But what if? What if? I still do not know the answer forty years later. But I do know it would have meant a decision which pure chance enabled me to avoid.

Late one afternoon on one of the first days of February 1941 I climbed over the wall of the Warsaw ghetto. If my memory does not deceive me it was at the point where Panska Street forks off from the wide Marszalkowska Street. It could be one turning before or one after. On the left there was a confectioner's shop, once Polish, now German. Like all the other side streets Panska Street went some 20 meters or so away from Marszalkowska Street and formed a cul-de-sac with the ghetto wall. There were ruined houses and somewhere there was a breach on one side of the wall watched over by a Polish policeman — I photographed it on some other day. It was already dark. Snow was falling but it was not cold. I went along the side street and found the breach. I stood there undecided. I was in uniform. The Polish policeman asked me in stuttering German what I was doing. I answered in broken Polish. He looked along the street, took note of the situation, and with hand and eye gave me a quick signal. 'Raz, dwa ...', one, two ... I jumped onto the heap of rubble and down the other side.

I was in the ghetto.

A Jewish policeman who was on duty there greeted the German soldier who had suddenly appeared from the other side of the wall in strict military fashion. I said good evening to him and went on into the deserted Panska Street.

Much of the area was in ruins. At the next corner I found some people. On their right arms they wore the white bands bearing the star of David. They pulled off their hats and caps as soon as they saw me. This was one of the regulations made by the German Occupation administration. I felt ashamed but there was nothing I could do about it. I stopped a horse-drawn cab, hid myself as best I could in the shadow of its clumsy roof and told the driver to take me to Dzielna Street. The cab went along faintly lit overcrowded streets. Frightened, I looked around me. I was in an area it was strictly forbidden to enter. I could not think of a single excuse should I be discovered. Court martial was certain. But this was not the reason for my fear, or only rather remotely. What really frightened me was to be confronted now by the whole truth. The truth was there all around me in the thousands of human wretches who in the

dim light of those streets seemed almost to merge into a single mass.
There I was, right in the middle of the terrible secret of the German
power-machine. I was frightened of the truth which was soon to
confront me in Dzielna Street. But I wanted to know the truth.

There was one problem. In order to get to my destination the cab had to
leave the ghetto and go through part of the 'Aryan' sector before it
entered the ghetto again; that meant through two German checkpoints.
The driver said that would be no difficulty for a German soldier. I was
aware of the danger only at the last minute when the gate was already
in sight. I had the cab turn round and was driven back to where we had
started. The driver had no change for the note I wanted to pay him with.
Nearby there was a shop, I believe it was a butcher's or some kind of
general store. A naked lamp hung from the ceiling, burning with a dull
glow. The weak yellow light lit the gaunt faces straining to attempt some
sort of smile. I could see that the people were frightened of me and
reminded myself that I was in uniform. I was able to relieve the tension
after exchanging a few words. They gave me the change I needed.

My mother was a small woman, in old age still fine-featured and with
something of a stoop. She had travelled a lot, her eyes were very
intelligent, and as she grew old she still continued to dress and to use
make-up in a rather too youthful way. She was one of those pale elderly
ladies one meets at spas, whose rouge and pencilled eyebrows one
finds somewhat pathetic. As I was turning to leave, a small, fine-featured
woman who looked exactly like her put her hand on my arm and asked
me in good German: 'Tell me please, soldier, what's all this about and
how long will it go on?'

She had arrived here a few days before, I have no idea from where,
utterly at a loss, quite unable to fathom what had happened to her. I
cannot put to paper the answer I gave. It was foolish, of no value, a false
hope clean against my innermost convictions. Roosevelt had recently
announced the Four Freedoms. America. I said 'Not long' and knew I
was lying. She wept. I went back to the cab, paid the fare, and jumped
back over the wall into legality.

Some days later I saw the same Polish policeman on guard at the same
place. It was six o'clock and already dark. Thus I entered the ghetto for
the second time. It was very cold. Now my memory lets me down. I
cannot remember clearly how I got to Dzielna Street or through which
side streets I walked. I believe there was a wooden bridge that went
over the 'Aryan' corridor. Or it may be that I saw this bridge later in a
photo of the Cracow ghetto. One gets confused. Anyway, I got there and
found number 27. Dimly I still remember how painful the journey was;
the obsequious respect my uniform demanded, how people retreated
into doorways or crossed over to the other side of the road as I
approached. I felt the eyes of those behind me burning into my back.
Here *I* was a pariah.

Dzielna Street was not a wide street and not very busy. The house on
the right of number 27 had been bombed, a heap of rubble now covered
in snow. It was not possible to get to number 27 from the street; the
entrance was along the side adjoining the rubble. As I approached the

door I noticed an old man. He was wearing a black caftan and had a white beard. He removed his hat and bowed in a way that pained my heart. I noticed that the hand holding the hat was trembling violently. Certainly he was unable to distinguish between the many German uniforms, nor the insignia of rank. Mine was only the star of a Private first class. The front door was ajar and I could see other people inside trying to get a glimpse of whoever was outside.

My boots, my grey overcoat, my black belt and service cap felt like lead. Just then the Yiddish word for 'fear' came into my mind, *moire*. I used it and tried to assure the man that nobody need be frightened, that I was a friend. I asked who he was. He was the caretaker, responsible for the building and the people in it. I offered him cigarettes. At that time there were lots of American cigarettes in Warsaw, Camels and Lucky Strikes. He did not accept, but continued standing there hat in hand.

I asked after Marguitta Olsiańska and tried to explain in broken Polish that I wanted to get in touch with a dear friend from before the war. I could not see if this reassured or frightened him, but, bowing to me in the same shocking way as before, he said he would take me to her right away.

The front door had neither chain nor lock. 'All doors must be left unlocked and open', I was told in answer to my question. We went along a dark hallway and climbed some wooden stairs. Hall and stairway were crowded with people. They were lying on the floor, sitting on the steps of the stairway, huddled in coats, blankets and rags. Women held their muffled-up children on their laps. Everyone pressed to one side to make way for me. Some tried to stand up, as indeed they were obliged to, in the presence of a German. Clumsily I tried to tell them to take no notice of me. I could not look anyone in the face. They surged all around me as if in a nightmare as I walked up those stairs. The inside doors were also without locks or handles. A small boy held a door wide open; my presence and my purpose in that house were already known. I walked into a large room, once the noble drawing room of a well-to-do family.

The room was being lived in by several families or groups who had taken over space in the corners and along the walls. There were just two chairs, an oval table with a central support, and a couch that stood in the middle of the room, in which there were about twenty people. Most of them slept on the bare parquet floor on blankets or newspapers, covering themselves with coats. In one corner sat a woman trying to comfort a crying child. Then it struck me that in this room there were only women, girls and children. At a glance one could see their deprivation, the absence of any hygienic facilities, and their wretchedness. The cold air was suffocating. The windows were shut and nailed down, the glass in them had been painted over with thick blue paint.

Later I learnt that the windows had been nailed down and painted over because they looked out onto the Pawiak, the prison of the German Gestapo and SD. The name Pawiak struck terror in the heart during the German occupation of the city. The whole building complex bordered

onto the back of Dzielna Street and would have afforded a view into it from the windows at the back of the house. 'We always hear the shooting', one of the people in the room told me. 'Often during the day, more frequently at night, and screams too, when the city is quiet.'

And the people crowded in that room told me more. Marguitta's mother brewed some tea on an oil stove. Though the room was so over-crowded it was still cold. We sat in our overcoats and I was glad to keep mine on because it covered the swastika above the breast pocket of my uniform. What I learnt from the stories of those women — of their personal suffering and of what had befallen them — of how they had ended up in this oppressive room, this airless dungeon with its permanently locked high blue windows, its ornate ceiling, grey floor, threadbare carpet and worn furniture, its inhabitants sleeping or sitting quietly with empty faces — what those women told me that evening destroyed the last vestige of any belief I'd had in a Germany which would not allow such things to happen.

They spoke of Germans without making any distinction as to whether they were from the army, the police, or anywhere else. Whoever it was that had ruthlessly expelled them from wherever they had come from, they were Germans. One of the women had lost her son — he had not reached twenty, she said — gunned down on the spot as he tried to protect his mother from the blows of the Germans. Before that her husband had been dragged out of the house and since then had disappeared without trace. Another woman had owned a good apartment in a modern building in the western part of Warsaw. One day two women appeared, secretaries in the German administration, presenting her with an order demanding that she leave the place within the hour, taking nothing with her but a suitcase with a few personal items. This happened before Fischer's order concentrating the Jews in one area, and the woman was able to find out discreetly that the two who had moved in had seized possession of the furniture, linen, crockery, carpets, radio, pictures, silver, books and everything else. In passing it should be said this happened every day in German-occupied Poland. The two Olsiańskas, who had lived in Dzielna Street since before the war, were troubled most by the oppressive lack of space, the dreadful nearness of Pawiak prison, and the uncertainty of their fate.

Everyone who joined in spoke of hunger. At that time the ghetto had not long been cut off so stocks of food were still held here and there, but were on sale at prices which were prohibitive to all but a few people living there. Those who had nothing to sell or exchange such as jewellery, fur coats or households items would quite simply starve — some sooner, some later. Some died in the snow from exposure, some were carried out from wherever they had found refuge, laid out naked (even the rags they had worn had some value) on the kerb and covered with newspaper so that they could be picked up by the death-carts and taken to the cemetery. A label was tied to their right toe with their name, if it was known, this was entered in the Jewish Council's register of deaths; the body was then thrown into the lime pits. The women told me about the occasional raids which the Germans organized in the ghetto, the way they would chase people along the street and laugh as

they shot at them, especially if their victims were slightly clumsy, if they were wearing curls round their temples or caftans or if they tumbled head over heels as they fell.

It was too much and now it is too long ago for me to remember all the details. But I can still picture those women crouching all around me as I sat on the couch they had offered me, and I still remember how keenly everything they told me struck home, increasing my shame and despair. All of this was an undisguised, diabolical crime.

I went away certain that all of these wretched people had been condemned, consciously and deliberately condemned, to death. Seeing how far the limits of humanity had already been pushed, what was to prevent this hatred from going to the utmost extreme?

According to Nazi philosophy, once they had been declared vermin and useless animals, what possible place could there be in the 'New German order' for these despised creatures? A 'Jewish settlement area' somewhere in the hectically Germanized administration was just inconceivable. What I learnt from those women in that awful room was but confirmation of what I, as a German in the German armed forces, had seen for myself, and which I could have deduced without effort. I was convinced that we were planning to leave the Warsaw ghetto and all the other ghettos in Poland to die of starvation. In this certainty I returned to my unit. On my belt buckle were the words 'God with us'.

I talked with Köhler and Krause. They tried to calm me down. Often I wished that I had never sought the truth, but what I now knew could never be forgotten. At the end of February 1941 my wife joined me in Warsaw. We made crazy plans, without the remotest chance of realizing them. Then once again I went into the ghetto. Again I was in uniform. However, this time I went in broad daylight and with my camera. Looking back, I fail to understand how I could have been so reckless. I know now, though it did not occur to me, then, that members of the Gestapo, SS and SD always patrolled the ghetto, in uniform or plain clothes, and I could have been arrested. I suppose I had not really thought through all the consequences. But some recklessness which is quite foreign to me today drove me to it, and the echo which I can still hear today was my fear that a time might come when no one would believe what had happened, and that it must be preserved, placed beyond doubt, for posterity. The greater part of the pictures contained in this book are the result of this compulsion.

The photographs speak for themselves. I can no longer remember many of the details of that adventure. It lasted about two hours. I marched through the streets of the ghetto, a grotesque object, a sort of automaton from another planet, and the crowded street parted before me, shrank away from me, stood aside for me, looked at me, surprised, nervous or amused. Some children and youths, keeping a certain distance followed me. Every now and then I stopped to take a photograph: street scenes, wretched children, a remarkable head, a poverty-stricken face.

There were difficulties. Years later I photographed fishermen in Holland, priests in Ceylon, Indians in Bolivia. I would go up to them and politely ask permission. Never any problem. But in Warsaw, however polite I

tried to be, my request would always sound like a command. I spoke to a group of men who for all their reduced circumstances, still managed to retain their dignity; I asked, as politely as I could, to be allowed to take a portrait, but it made no difference, they bore it with the same kind of resignation as if I were ordering their arrest. They took their caps off and stood stock still, and I had to ask them to put them back on again. Then the situation became even more uncomfortable. Some of the children who had been following me to see what I was doing, now went in front of me like heralds. They wanted to be helpful and earn a few coins. When one of them saw someone who they thought I would want to photograph they would lead him in my direction, telling him while they did so, that he should not take his hat off. And I would photograph him. But the turn my visit was taking brought despair into my heart. The mark of Cain, my uniform, burned on my body. I chased the lads away but they came back. On I went, the crowd of curious people with me growing bigger and bigger.

On the steps of a large building I photographed two members of the so-called ghetto police, a Jewish unit established by the Germans to keep civil order. As I went on my way one of them came after me, increasing my discomfort even more. Then he overtook me, waving his arms, ordering the bystanders as far as I could tell, to move on and leave me alone. Then he turned threateningly on the tribe of lads that had been following me.

I spoke to him and asked him to leave me alone. Standing to attention, he replied in fairly good German: 'With respect, sir, but I can't leave you alone. I must guard you.'

I told him there was no need for him to stand to attention, nor did I need protection. I was harmless. I spoke as any German civilian would trying to convince a policeman that he was not a suspicious character. The man from the Jewish police was so convinced that he even risked a smile, and speaking confidentially he said: 'That's not the point. But if anything should happen to you here in the ghetto ...'

'But nobody is going to do me any harm.'

'But if ...' he insisted, and then paused.

'Well, go on', I said.

He looked at me in a penetrating sort of way. 'Then the ghetto will be held responsible', he said, so quietly that no one else could hear him, but very deliberately and seriously. 'That is why I must look after you and see that nothing happens to you.'

We came to an agreement that he should do his duty as discreetly as possible, and from that moment on he kept a decent distance but never for a moment let me out of his sight. He quietly broke up the group who had been following me, got rid of the little heralds who had gone on in front of me, and in the end I was glad to have him there. These photographs have again brought his face to my mind, the face of a pleased young man, in which it seemed I could see something tragic: a premonition of the diabolical fate of which men of this Jewish police force were already condemned to be the instruments, to drive their

fellow sufferers to the German slaughterhouse, and finally to go the
same way themselves.
When the hindrances and problems connected with my expedition had
been overcome I restricted my photographing to street scenes, poor
children, occasional groups we happened to pass. It had become too
painful for all parties to take any more portraits.

Apart from what the photographs themselves tell there is little more to
say of this expedition. Although the cruel conditions in the ghetto
deteriorated rapidly when the Russian campaign began, they were
already unimaginably awful when I made this visit. Certainly, at the time
there were still some decently clothed and well-fed people to be seen in
the ghetto, but one noticed them right away because they were different.
There were also places of entertainment, theatres, newspapers,
delicacies to be had on the black market, and even balloons. If at any
time between when I took these photographs and when they were
enlarged, anyone had asked me if I had seen a balloon-pedlar in the
Warsaw ghetto, the idea would have struck me as absurd, and I could
have sworn on oath that I hadn't. But there it is in the photograph: even
in the Warsaw ghetto, you could get balloons. How careful one has to be
with one's memories! But, looking back, knowing what we do about the
relentless extermination of children in the ghetto, what can we make of
those balloons?

Hovering above a sea of misery and despair, they seem like a symbol of
all that is exceptional. The overwhelming majority of the people I saw in
the teeming and packed streets and alleys of the ghetto were in torn and
tattered clothing, and thousands more had nothing but rags, were
huddled, lying or sleeping on the ground, sobbing, pleading for charity,
waiting in vain. Their feet wrapped in sacking, their eyes big and
hungry, their cheeks hollow, they had nowhere to go to escape the bitter
cold. I squatted down beside one of these heartbreaking children. He
told me he had been singing songs all day. I counted the coins in his
beggar's cap: 26 groszy, at that time worth 13 pfennigs. Five years later,
speaking on the radio, I said: 'prices of staples were sky-high. In terms
of German money a loaf of bread cost 200 marks, a pair of shoes in fair
condition, 2000 marks, a pound of beef 600 marks. Many Jews
committed suicide in the depths of despair. The price of a dose of
potassium cyanide was 4000 marks.

These children, these tens of thousands of children of the Warsaw
ghetto, condemned to freeze or starve to death, were not the victims of
an all-powerful destiny or a destruction ordained by fate, but of carefully
orchestrated extermination. The misery they suffered was not caused by
any shortage of housing space, clothing, medicines or food, nor by the
general shortages prevailing in German-occupied Europe as a whole. It
was deliberately, artificially created by the Germans and ruthlessly
imposed on these helpless prisoners behind the walls of the ghetto.

This was a crime of such unrivalled proportions that my comrades
Köhler and Krause could hardly believe me when on my return I told
them of my experiences. In our concealed darkroom they looked at the
tiny film strips. They wanted to see these things for themselves. But I
felt I had not enough strength to go through the whole thing again. Now

I had the abyss behind me I was much more aware of the dangers.

Nevertheless, another opportunity to visit the ghetto occurred. As I mentioned before, my then wife had come to Warsaw to do her civil service which happened to be in the inner circles of the Warsaw government of occupation. Turning the greed of government officials to her advantage, she found easy ways of doing business, particularly with Leica cameras, and, with the aid of a few specious promises, was able to 'organize' a highly dubious pass. This was a permit enabling four named soldiers from ... Unit, Army post code 21022, to enter the ghetto for the purpose of making certain purchases on behalf of the army. It was signed and sealed; a perfect official-looking document. Appended to it were the following instructions: 'To be destroyed after use. Explanation if necessary: purchase of cigarettes and liquor for social purposes.' Both of these items were much more expensive in the ghetto than in the rest of the city, but anyone in a position to ask questions knew that a German soldier on duty could easily confiscate whatever he liked from a Jew.

Though our permit had been quite illegally obtained it was, in fact, quite genuine, and had been issued by the competent government department. All four of us were mentioned by name, though I have to confess that I can no longer recall the name of the fourth. When I look at the photograph on which to the left of Krause and me the fourth man can be seen, I think I can still hear his voice, and his name is on the tip of my tongue. I remember the calm, deliberate manner of this comrade and conspirator, whose political indignation about human motives still had a certain Germanness about it.

Then, quite openly and without any difficulties, on the 1 March 1941, our group went into the Warsaw ghetto. The German police at the entrance cast an official eye over the pass we showed and said, 'Macht's gut' (Have a good time). That Köhler, Krause and I had cameras around our necks meant nothing to him. On that day several more of the photographs in this book were taken. Köhler and Krause each shot a film or two. I have no idea what happened to my comrades or to the photographs they took; the war later separated us.

But something happened, a consequence of all this, that has to be reported. Some time later one of the others, I can no longer remember whether it was Köhler or Krause (it could even have been some other member of our unit), went to the ghetto cemetery alone to record on film how the naked bodies left out on the streets in the morning were bundled off in handcarts, how these skeletons, thin layers of skin stretched over them, were piled up and then thrown into the mass graves.

Some 9 × 12 cm enlargements of this series of photographs were made in our darkroom. A few of them were in my hands. Somehow, some of these pictures got passed around and promptly fell into the hands of an unreliable member of the company who just as promptly reported them. An investigation was held. The photographer defended himself with the lame excuse that it seemed an interesting subject and he took the photographs with no thought for the consequences, especially as access

to the cemetery was not restricted. The negatives were confiscated and anybody who possessed prints had to surrender them and sign a sworn statement that they had no more copies. Thus the matter was apparently settled. But it is worth repeating what the responsible officer had to say on the matter to those concerned.

He did not waste any words on the awful scenes documented in the photographs. These were for him, rightly, a matter of general knowledge; and, wrongly, taken for granted by every German soldier. What concerned him was to make clear to us the unforeseeable damage Germany might suffer if such pictures got into enemy hands and were used for propaganda purposes. He did not for a moment consider the possibility that they could cause disgust in Germany itself.

After this there were no more expeditions into the ghetto. The negatives remained in their hiding place. For over forty years they quietly guarded the ghostly backdrop of houses which have long since crumbled to dust, the faces and shapes of human beings who used to walk, talk and live there, crouching on the kerbside, entreating us and looking towards our present with unfathomable eyes. My intention in publishing these documents is polemical. They are still testimony to the fear I had when I took them long ago: that people might not believe that all this ever happened.

During the war I went to Warsaw several more times. On one occasion I broke my journey there on the way back from Russia to the regimental replacement depot in Potsdam shortly before winter began in 1941. I was there again in the summer of 1942 and in spring 1943, curiously enough on both of these occasions in plain clothes. My wife was still serving with officials of the occupation administration so I was allowed to spend my leave there, having been given the permit to wear civilian clothes that soldiers usually received. My 1943 visit was very short, I had to go on to Lvov because in the meantime my wife had been transferred there. The last time I saw Warsaw was in November 1944.

In Warsaw the changes in the fortunes of war were clearly to be seen. In late autumn 1941, when German forces were penetrating ever more deeply and irresistably into the Russian heartland and were threatening Moscow, the treatment of those passing through the gates of the ghetto was even more brutal. Until the actual invasion of the Soviet Union a waiting game had been played. But now all inhibitions were simply cast aside. In the East the special units were already raging. The mass graves were being filled with tens and hundreds of thousands of massacred Jews, and it was obvious that the German police in Warsaw had become infected by this orgy of destruction. What was now happening in the East was in no way secret; it was, to a greater or lesser degree, general knowledge among troops both at and behind the front.

From my experience it is utterly mistaken to make a kind of myth of the vaunted perfection and discipline of the German army. On the Eastern front, with victory supposedly in sight, there was not the least effort made to hide or keep secret the extermination of the Jews. Wherever the mass graves were dug and the Jewish population was slaughtered, men, women and children alike, you would always find soldiers, railway workers, Organization Todt men, civilians sometimes dressed only in bathing trunks and frequently with their cameras, gathering to witness this monstrous spectacle. The murder squads had no objection, the burial grounds were not off-limits, nobody was chased away. No doubt it was generally assumed that no matter what uniform the spectator happened to be wearing, as a follower of Hitler he would have nothing against whatever was happening.

Of course this was mistaken. What happened at these mass killings, the fact of these dreadful mass graves which buried a whole race, was soon· generally known, the word spread by those who had borne witness. Only a soldier who was deaf and blind could have remained in ignorance. It was talked about in typical army jargon and I can conceive of no one serving in the army at that time who would not have

understood the full implications of such expressions as 'resettle', 'liquidate', 'special treatment', 'do away with' and 'chase through the chimney'. In fact even if it had been the intention of the people at the top to keep the whole thing secret, the very extent of the campaign would have made this impossible. The army and all the other services were everywhere, at and behind the Eastern front, and they were bound to come across the exterminators. The 'de-Jewification' of entire districts, the places where they were corralled, the trucks that took them away, the gunshots ringing out for days on end at the mass graves, none of these could remain forever unnoticed and unexplained. I myself saw a gathering of wretched Jews at an improvised assembly point near Smolensk. The earth was hard with frozen mud. The people, who had been rounded up in nearby villages, stood there freezing, awaiting their fate. Most of them had no overcoats, some of the smaller children had been wrapped up in the coats of adults, others were in rags. I asked one of the guards, a member of the armed SS:

'What's going on?'

He turned tactfully to one side so that only I could hear what he said: 'They are to be done away with.'

It was nothing new. There was no secret — how could there be in something so widely known, so casually discussed, which was part of the standard mental kit carried by millions of soldiers? (How heavily this kit weighed on the shoulders of the individual soldier is quite another matter.) Such statements as 'The German people knew nothing about it', or 'If only the German people had known what was going on', quite clearly do not hold water. Millions of German soldiers serving in the East returned to Germany on leave, wounded, or for home service. Could they possibly, to a man, have kept their own counsel, not breathing a word even to their intimate friends? What they actually felt when they shared their knowledge, that again is another matter. People knew what was going on, and when it came to the German Jews being forced out of their houses for 'resettlement in the East', there could scarcely be any doubt as to their true fate.

In 1943 I myself witnessed the forcible removal of a Jewish family from the Neue Winterfeldtstrasse in Berlin. Easily recognizable by the star of David on their arms, they were told to gather together a few personal effects and get into the waiting truck. A few housewives with shopping-bags and one or two passers-by looked on. As quickly as they could and with bowed heads the Jews passed in front of those staring eyes and climbed into the truck. I looked at the onlookers; the satisfied expressions on the faces of those worthy middle-class ladies made such a deep impression on me that, though I am no artist, I attempted to make a sketch from memory. As the truck drove away, one of the women turned to her companion and with a conspiratorial glance at me, said: 'They're for the gas chambers, too.' I can still hear the total lack of regret in her voice.

People knew. The army commanders also knew what was happening in the areas under their command. Two orders, which have often been cited, demonstrate not only this knowledge but also the effect the extermination of the Jews was having on the German troops: the shame

and disgust felt by some, the approval and brutalizing effects felt by others. Sufficient disgust was expressed that it came to the attention of Field Marshall Walter von Reichenau, who on 10 October 1941 issued an army field order which described the 'extermination of Asiatic influences on European culture' as 'the essential purpose of the campaign against the Jewish-Bolshevik system', adding, by way of appeasement: 'There is consequently a job to be done which is outside the scope of simple military duties.... Therefore the soldier must fully appreciate the necessity for the tough but justified sanctions against the sub-human Jews.'

And the fact that army personnel regularly stood and watched, took photographs, and even participated in the atrocities, the whole range of brutalizing effects on the army, is shown in Field Marshall Gerd von Rundstedt's field army order of 23 September 1941. This stated, among other things, that: 'Unauthorized action or participation by German soldiers in the excesses of the Ukrainian population against the Jews is forbidden, as are observation or taking photographs of special commandos in the execution of their orders.'

The increased brutality, as I have already said, was evident to me when in late autumn 1941 I once again saw the gates of the ghetto. The German police were less inhibited than they had been six months earlier. When I came to speak on the radio about it four years later — my memory was still fresh then — I said:

> On one occasion a white-bearded old man passed through the checkpoint on his way back from the city. The guard studied that old man's pass with tortuous deliberation to make his victim uncertain and afraid. The old man stood there, hat in hand, as required by the regulations and waited, trembling, for the usual kick. While this was going on other soldiers who were standing around started to hurl abuse and to make fun of the old man's beard. Then the guard started to look through his pockets and found part of a loaf of bread. That was forbidden, he barked, and accused him of having stolen the bread. The old man replied that he was hungry and someone had given it to him. 'You dirty liar!' answered the guard, pounding the old man so hard in the face that he staggered to one side. But that was not the worst of it. At this point those soldiers standing around watching started to cheer and roar with laughter. One soldier, whose face — that of a bourgeois paterfamilias — I will never forget, shouted encouragingly, 'Let him have it!' Encouraged, the guard was predictably not loath to oblige. With punches and kicks the old man was driven into the sentry box near the barrier. I turned my eyes away but stood there rooted to the spot. I could hear more blows and a sickening thud; then the guard returned to his post amid renewed applause. When I was able to look again I saw the old man lying unconscious in the sentry box. Blood was streaming from his mouth and nose and staining his white beard. During the next quarter of an hour the guard roused the old man several times only to knock him unconscious again, till finally he gave him a formidable kick which propelled him into the ghetto.

Inside the fence there were always small groups standing around

watching whatever was happening. Obviously their purpose was quite different from those on the other side of the barrier. Two young Jewish men and a woman detached themselves from the wretched gathering, picked up the unconscious man and carried him away.

I stress once more that all the time this was going on it was accompanied by laughter, applause and shouts of encouragement from the soldiers who were standing around, watching. I must also stress that this was not merely an isolated incident. Such scenes could be seen every day, every hour ... in fact in Warsaw they became so well known that army personnel, members of other services, as well as German government officials, thronged together to see this awful spectacle almost as if it were a free show. Often what took place was so inhuman that the utterly helpless Jews on the other side of the fence became enraged and their collective anger took on a threatening aspect. But for such eventualities precautions were already taken. Usually there was a motorbike, with a machine-gun mounted on the side-car, standing at the gate. With my own eyes I saw the German police open fire on the angry crowd without compunction. Later two women, a youth and a Jewish policeman were carried away dead.

This was in autumn 1941 and was observed through the eyes of a man who had been to Russia and had seen what would happen as the tragedy continued. In the summer of 1942, when I was spending my first leave with my wife in Warsaw, the decimation of the ghetto, the dispatch of its people to the gas chambers of Treblinka, was already under way. At the same time Jews from other parts of Europe were being gathered there. One day my wife took me to see something new. It was a sort of sluice or cage in which new arrivals were herded together to wait. Next to it was a walkway for those who lived outside the ghetto, with a wooden floor and a wire-mesh fence on one side. Behind this wire fence the apathetic Jewish captives stood, squatted or sat, wretched beyond belief, haggard and exhausted. The spectators passed along this walkway and could look inside. The wire mesh was too fine to allow more than two or three fingers to squeeze through. Along the fence women, adolescents and children stood and pleaded for a crust of bread from those who had come to look, clutching the wire fence with their fingers. I saw, poked through the grey fence, the entreating turmoil of little children's fingers and the thin bent ones of old women.

At this time in Warsaw the gassing of Jews was as openly talked about as the war situation. My wife told me that all the officials of the civilian administration, from the highest ranks down to secretaries, talked about Auschwitz and Treblinka and the liquidation of the Jews without the slightest demur. In the course of a day's work it just came up and was passed over in the same way as any other ordinary subject. Among the Poles themselves, growing more and more painfully aware of the bloody terror of the German occupation, there was no doubt as to the significance of the convoys leaving the ghetto. Several friends — former participants and patrons of an underground meeting place for Polish artists, the Gospoda Wloczegow — gave me some details in confidence. As was confirmed over and over again, it was an open secret.

I saw the ghetto again for the second to last time when I broke my journey to Lvov in Warsaw in spring 1943 and stayed there briefly. The great liquidation which had reduced the ghetto population by more than 310,000 victims was now over. The revolt of the survivors, about 70,000 of them, was in the near future. I wandered around the city in order to get an impression of it. This is what I said about Warsaw in my radio broadcast of November 1945:

> In the ghetto I was confronted with an awful emptiness. Where previously hundreds and thousands of people had swarmed like an anthill, there was now a wasteland of deserted streets. In the windows of abandoned homes fluttered the tattered remains of curtains. In the city itself I ascertained that there had been an appreciable fall in the price of jewellery, due to the fact that the SS had plundered everything valuable they could put their hands on during the liquidation and flooded the market. In places of entertainment in Warsaw at this time, large bills were often settled with a pair of gold bracelets or diamond rings.

In Lvov — Stalingrad and the Allied landings in North Africa had already darkened the horizon — the liquidation of the ghetto did not take place until the second half of June 1943. While on leave there and visiting my wife, I photographed the synagogue, destroyed after the Germans had marched in. This led to a very unpleasant episode involving the Gestapo. My wife had to endure a house search during which, smiling all the while she opened drawers and cupboards, revealing some old linen under which the negatives were hidden. The courage with which she protected these films should not, I think, go unremembered.

But I should also mention Lvov in connection with something else. After the destruction of the ghetto there and the people in it, my wife, who had returned to Berlin on leave, told me what she herself had seen and heard and everybody else in Lvov, including the Germans, had seen and heard too. She spoke of the slaughter which went on for days, of the red glow of fire over the ghetto, of the way in which the members of the Jewish Council had been publicly hanged from a balcony; one was, in fact, hanged twice because the rope broke. She reported that for days after the massacre trucks drove through the streets of the city loaded with loot or with the bodies of the murdered. Passers-by held their noses when they happened to meet these trucks. A sickening mixture of blood and other body fluids poured through the cracks in the trucks and left a trail on the roads behind them.

Even after the liquidation of the ghetto in Lvov there were still some Jews left. They worked at various factories set up by the Germans but were already condemned to death. My wife knew about this just as everyone else in the civilian administration did. She told me that these workers, men and women, had all been given numbers and that their extermination proceeded in sequence. Couples could tell by looking at their numbers who would be the first to go on their last journey.

The most dependable and sincere friend I had at that time was Werner Asendorf, a simple soldier who had married an American girl of Danish origin. He had a good job at army headquarters, reading and evaluating

American magazine and newspaper reports. He also had permission, rarely granted, to listen to foreign broadcasts as part of his duties, something which, if done clandestinely, would have cost an ordinary German his head. He was a passionate opponent of the Nazis; the duties he performed left him exceedingly well informed, and he was reckless in passing on what was broadcast on foreign stations. Together with his wife, Signe, and their two children he lived in his sister's house in Potsdam. When our work was done, we met almost every day at his home to listen to the BBC, or sat together in the air-raid shelter. We continued seeing one another frequently after the war till at last Asendorf was able to go to the United States. We corresponded for a while and then lost contact.

Asendorf was present when my wife returned to Berlin and told me what she had seen in Lvov. We discussed ways of getting the news out of Germany. Asendorf offered to introduce us to a Swiss journalist he had met at the Foreign Press Club in Berlin. We met one evening soon after, in the garden of an inn just outside Potsdam. In order to refresh my memory for the purpose of writing this book, I wrote in 1965 to Werner Asendorf, 3942 N.E. 11th Ave., Portland, Oregon. To give a picture of the situation as it was then I would like to quote a passage from my letter:

> ... I need your help urgently. I need to reconstruct a scene in which you took part because my own memory is rather hazy. During the second half of the war we had a meeting with a Swiss journalist whom you had brought along from the Foreign Press Club, at an inn, the so-called 'Meierei' near Potsdam. Marianne Heydecker was present, too. We told him what was happening to the Jews in Poland and, if I remember correctly, of the liquidation of the Lvov ghetto which Marianne herself had seen. When we eventually finished the Swiss journalist said something like: 'With all due respect that's too hard to believe.' Do you happen to remember who that Swiss journalist was, or else could you put down what you recall of that evening as carefully as possible? It would greatly help me in the book I am writing ...

The answer I received from Mrs Asendorf was a card bearing the words: 'Sorry he can't help you'. My friend had died seven years earlier on 28 February 1958. So what I record here is only fragmentary and cannot be recalled more precisely. Perhaps the Swiss journalist may read these words. In retrospect, I congratulate him on his honest faith in Germany.

The last time I saw Warsaw was on 20 November 1944. My company, Tank Destroyer Unit 337, was quartered in Konstancin near Piaseczno, formerly a holiday resort not far from Warsaw. The Warsaw insurrection led by General Bor-Komorowski had been bloodily crushed, the Russians were preparing their breakthrough over the Vistula. The people of Warsaw had been forced to evacuate the city. Against this backdrop of events, our commander, Captain Krause, a heel-clicking, hard-drinking officer, got the idea of trying to 'organize' some hard liquor in Warsaw. To enter the city was punishable by death, but Krause was able to arrange at Division headquarters a special permit for a lieutenant and five soldiers, signed personally by General Eberhard Kinzel.

Lieutenant Lutter, in command of the detail, included me in it because I knew the city. So I dare say I am one of the few people who went into the city, who saw the destroyed, dead and empty city, between evacuation and liberation by the Russians. A capital city in ruins, devoid of life, where all that greeted your words and footsteps was their own echo, seemed to me like something out of science fiction. Now it is past, but then it was all too real as we six, alone and shivering, explored this weird, uncanny scene. Now and again we could hear the distant roar of Russian guns. A burnt-out tram stared at us from the deserted Marszałkowska Street. Stillness. The rustling of small stones startled us. In the square in front of the burnt-out shell of the railway station the lid of a box leaned against a wall, bearing the words 'Looters will be shot'. Next to it was a dead body lying face down, arms and legs stretched out like mere forked extensions of the body itself. In the middle of the great street and on the shattered pavements we saw improvised wooden crosses with names written on them in pencil, sometimes with a withered plant in a pot. Our detail split up. With a comrade I picked my way through the rubble that had once been Marszałkowska Street. We shone our torches into cellars. We found discarded bandages, mouldy rags, a dreadful stench. We wandered through side streets, empty and deserted, climbed over ruins, homes empty and deserted, into yards and again into cellars. We found no vodka, in fact we were no longer looking for it, we were, as it were, looking for nothing; we were wandering in a groundless and limitless nightmare landscape.

The one-time ghetto lay there, nothing but rubble, razed to the ground and utterly still. Here and there a pillar or a girder remained in place. The outer limits of the ghetto disappeared in the mist of the November day. It was here I shot the last frame of the film on which I preserved the dead city of Warsaw.

I stood there looking at the ruins. Not even the air stirred. The silence screamed. In the distance the thunder of artillery, or was it just my heart beating in my throat?

My comrade gave me a nudge. We had to move on. But he, too, could say nothing. Only after we had found the way back and could see the waiting truck and the officer at the end of the street did he utter what had by then become a platitude: 'My God, what if we have to pay for all this?'

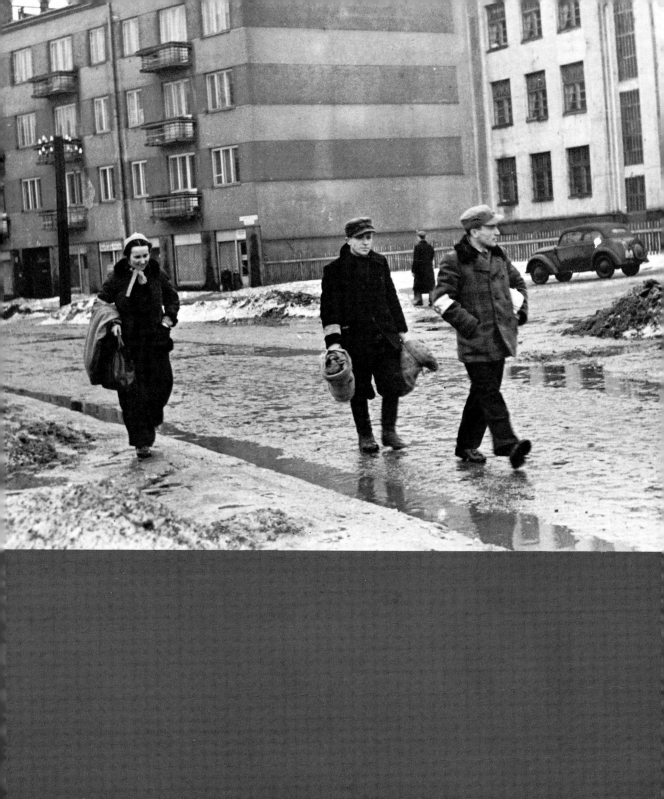

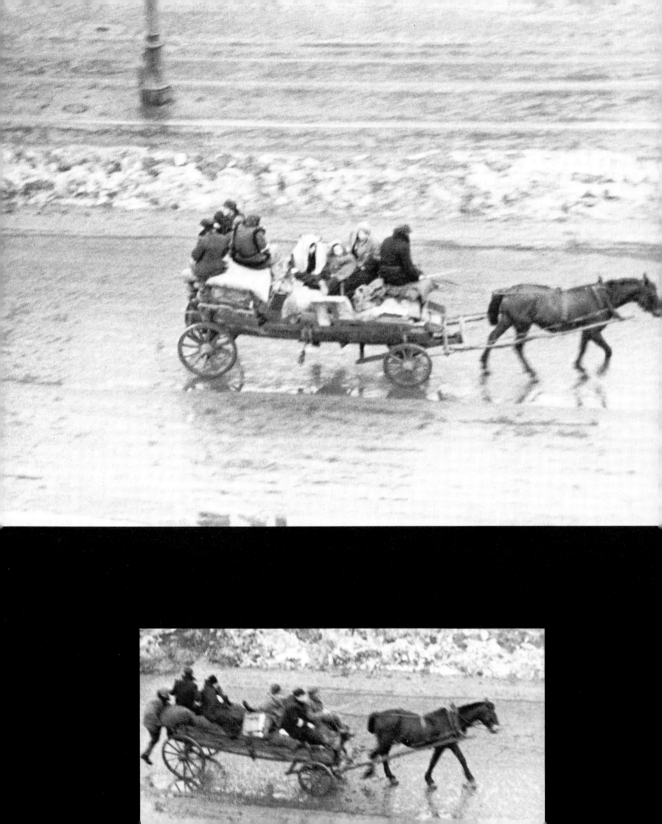

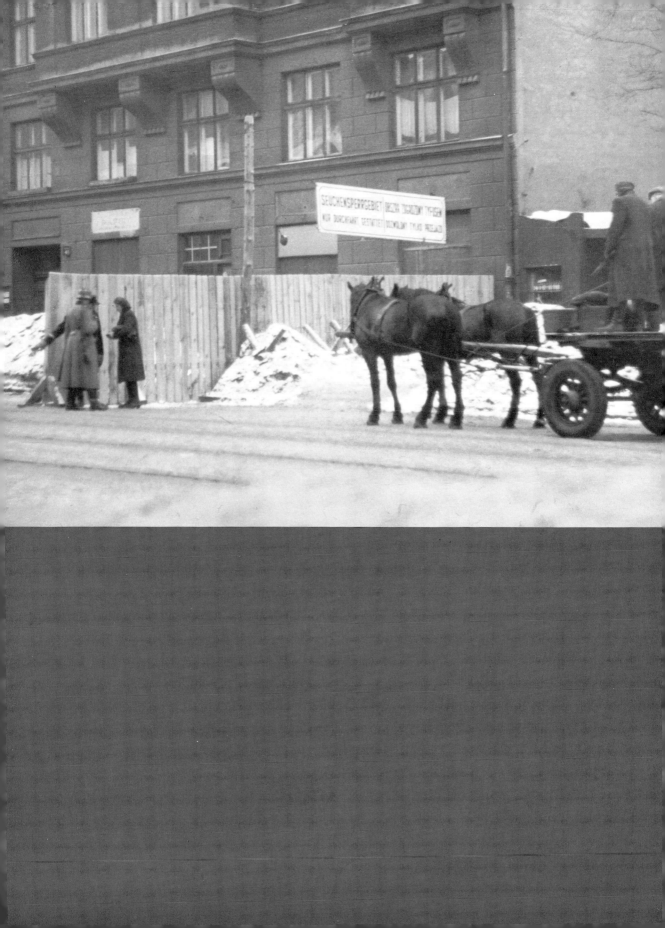

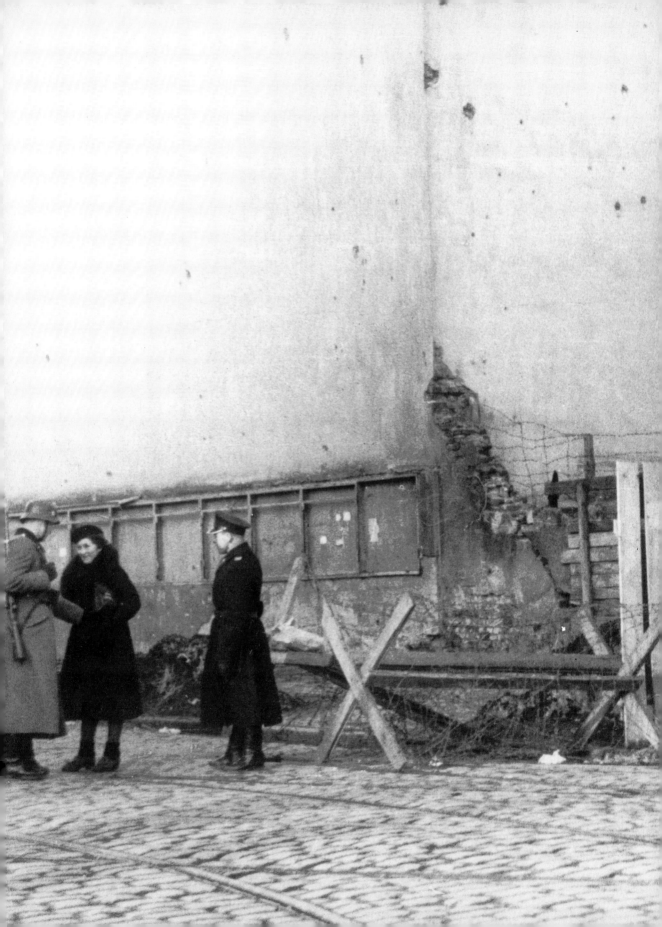

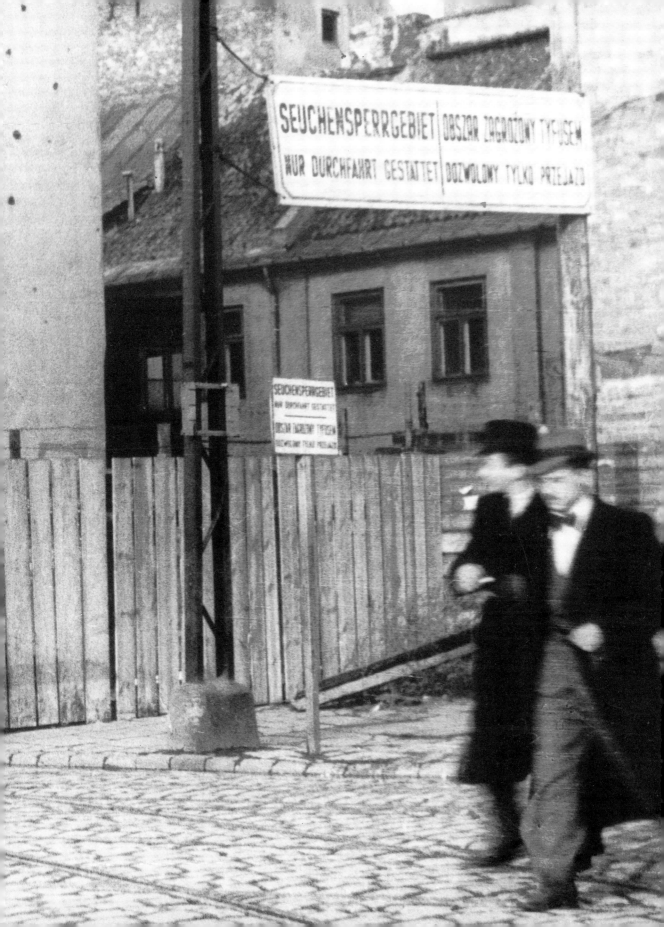

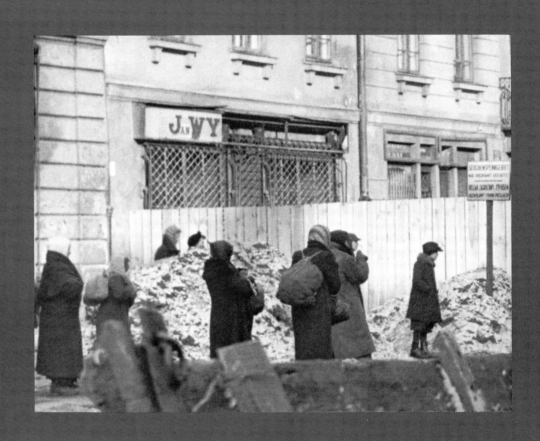

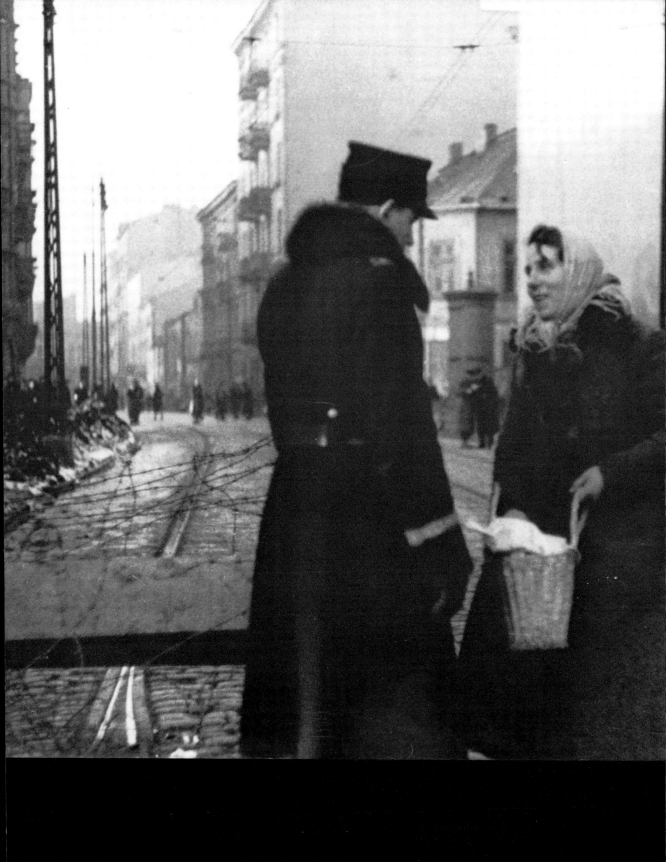

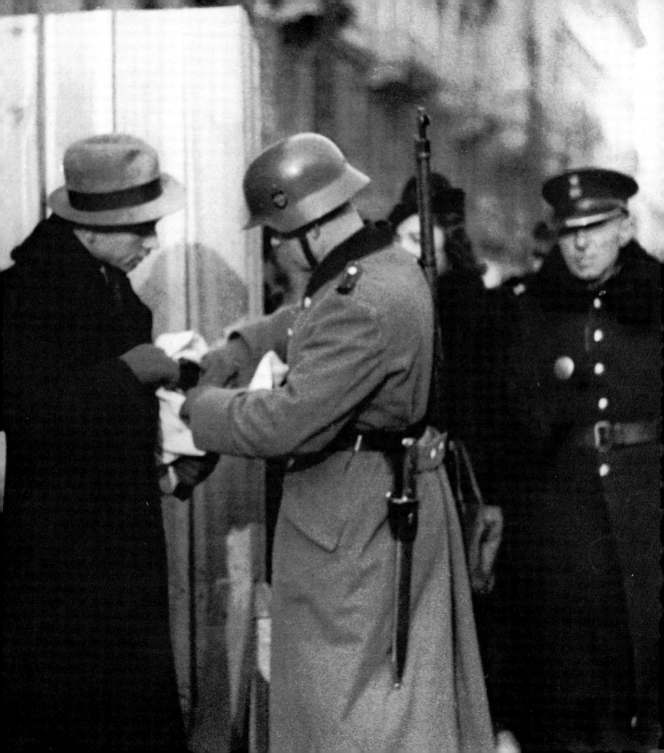

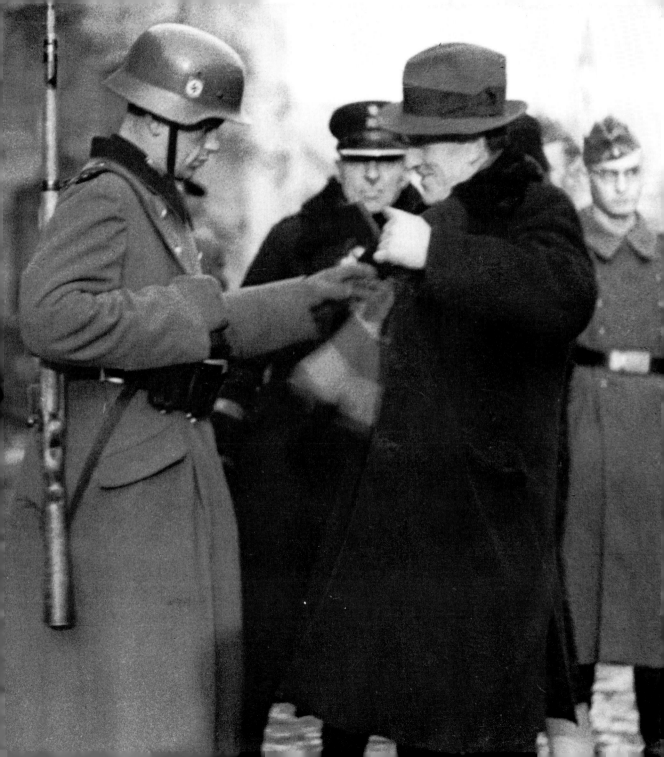

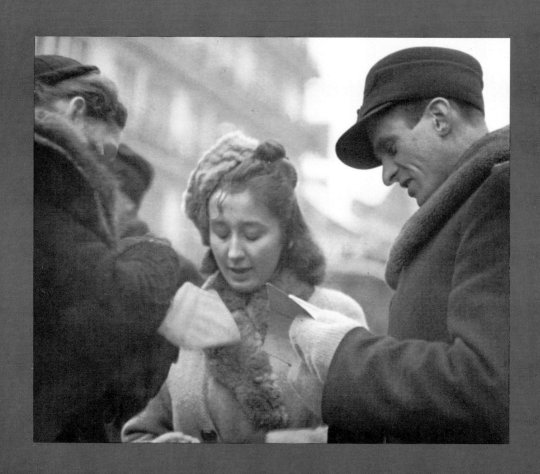

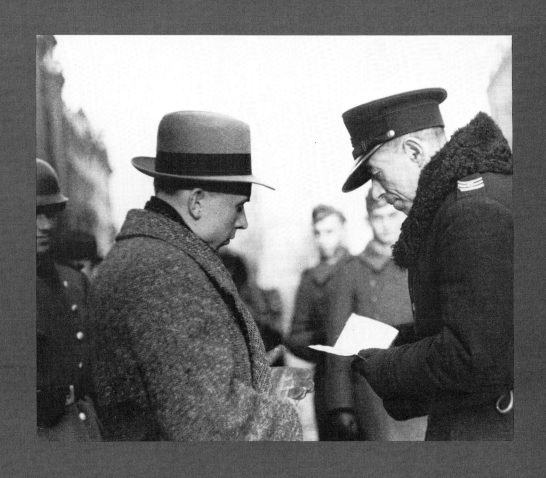

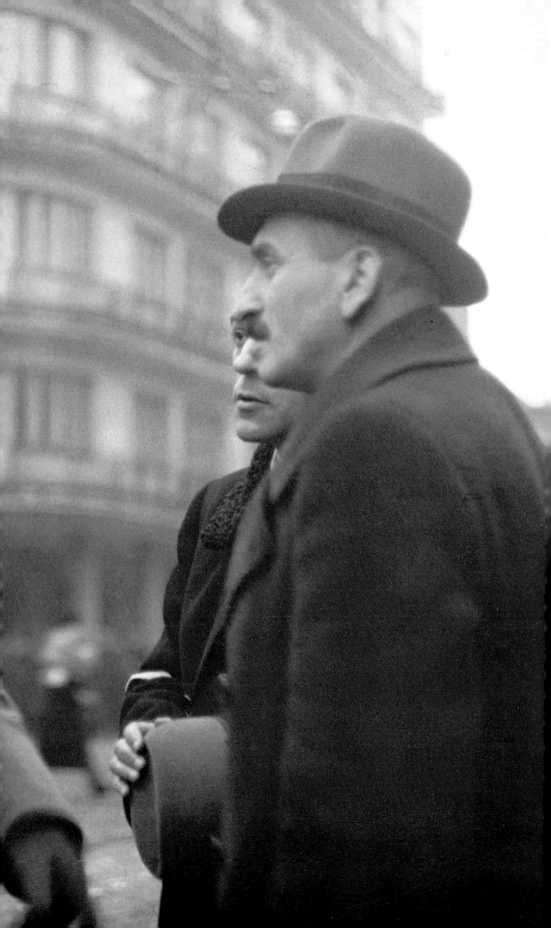

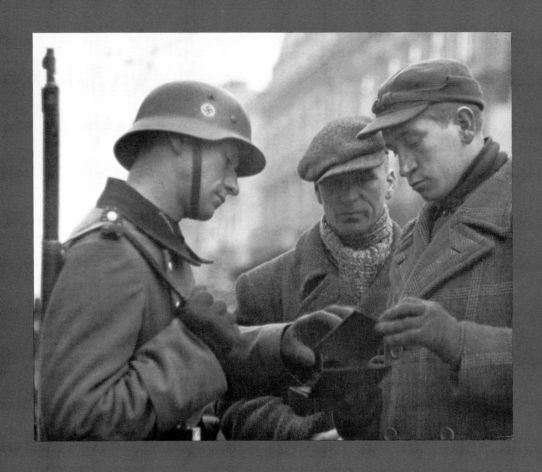

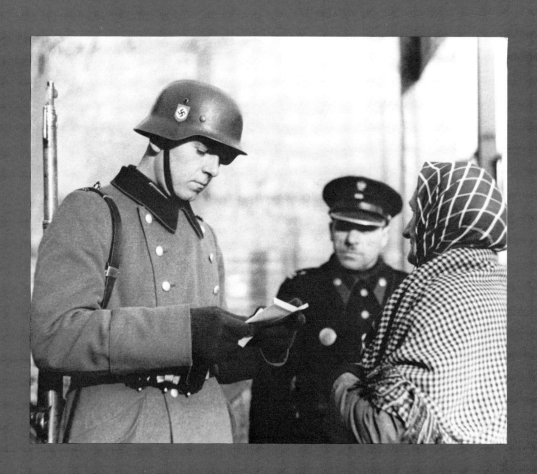

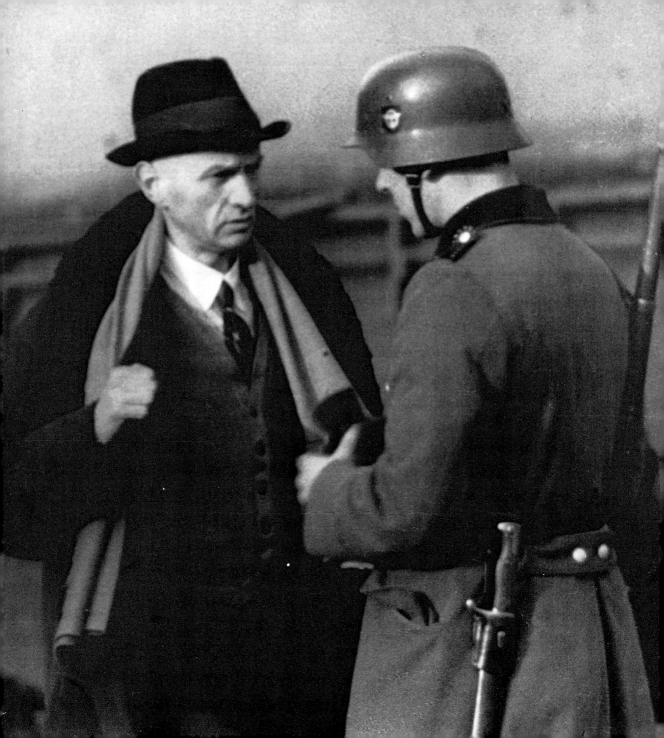

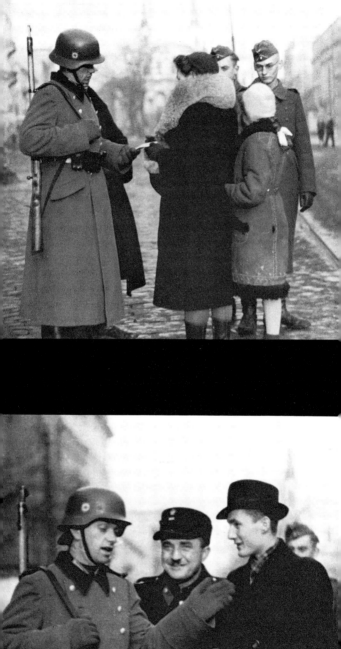
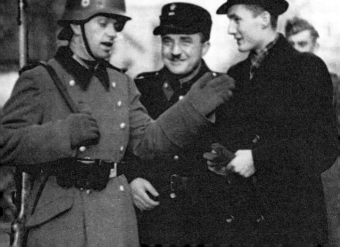

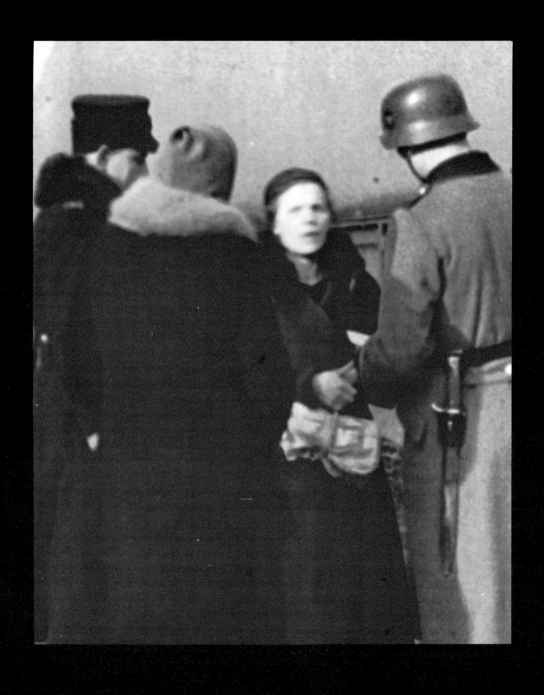

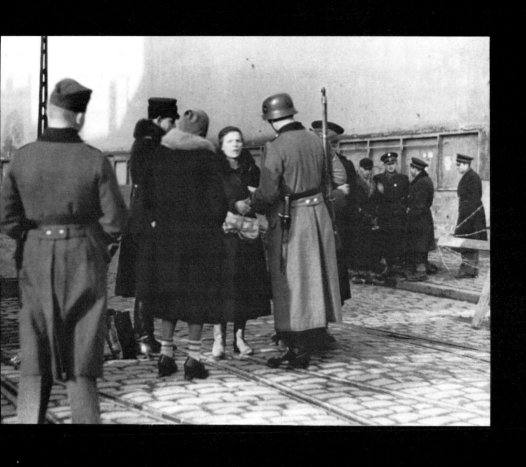

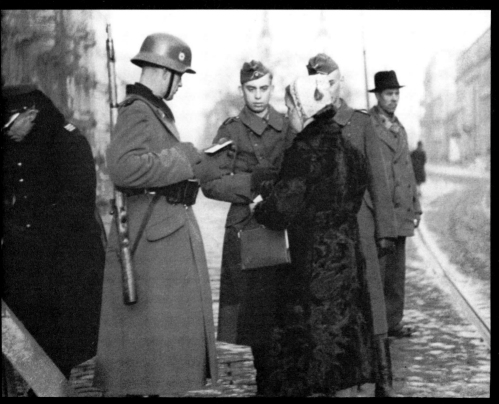

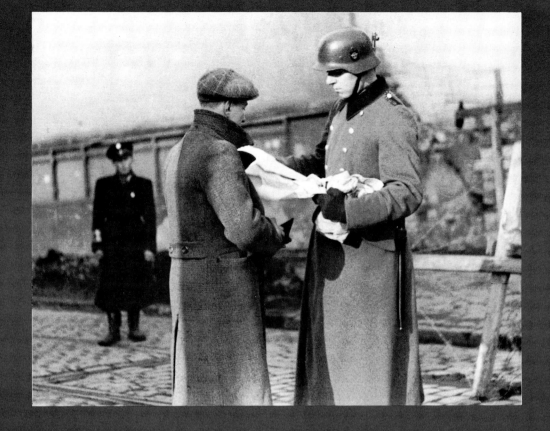

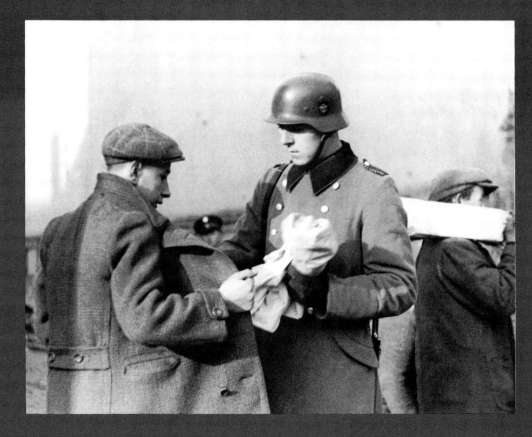

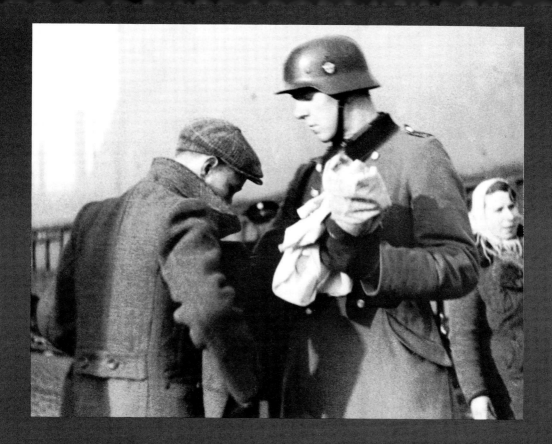

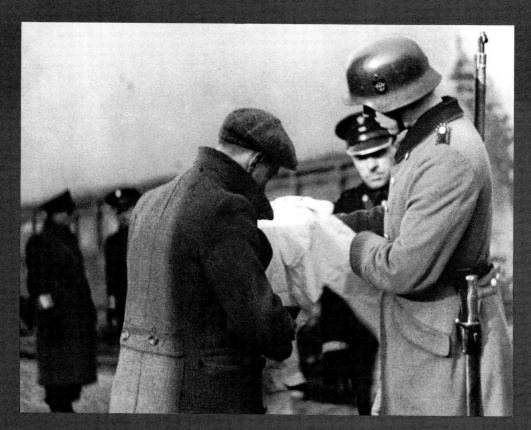

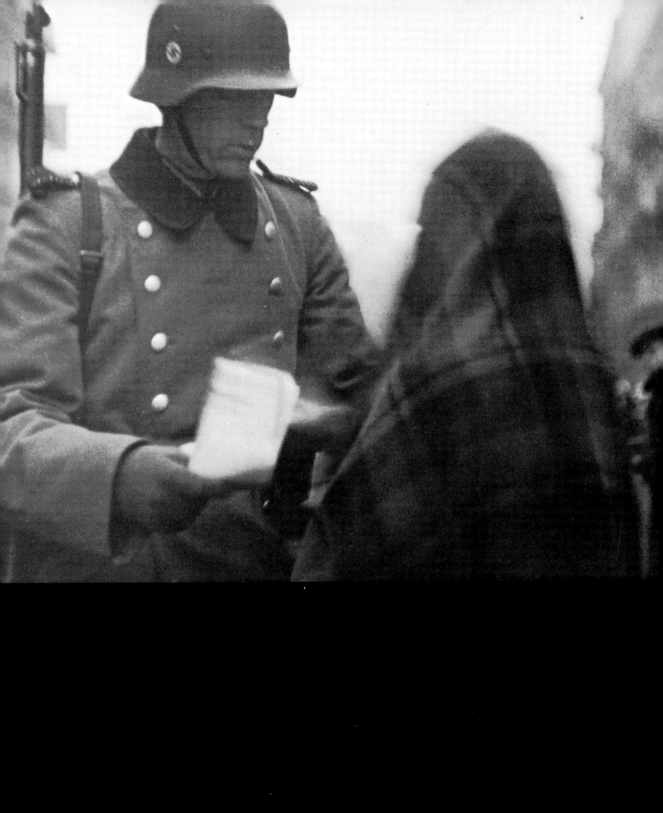

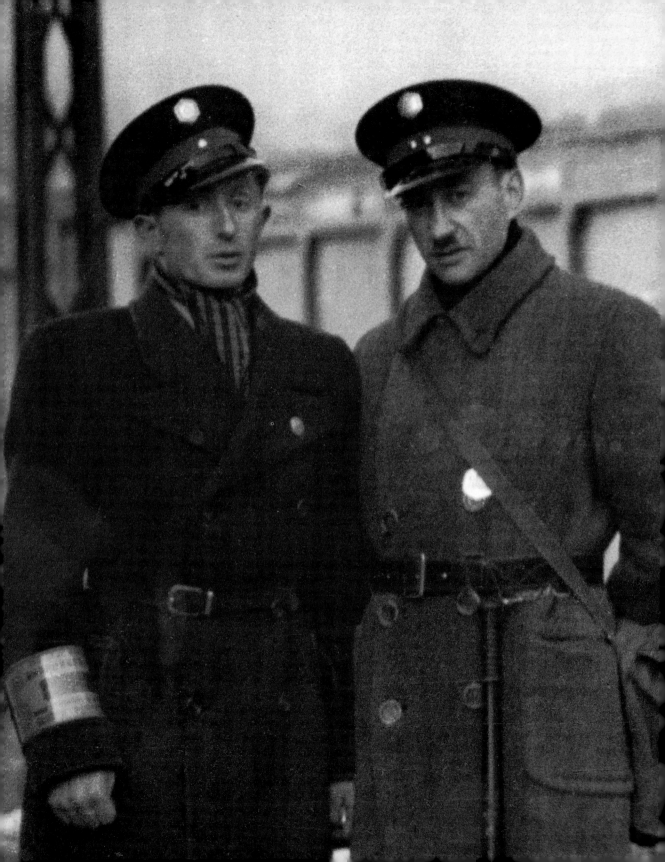

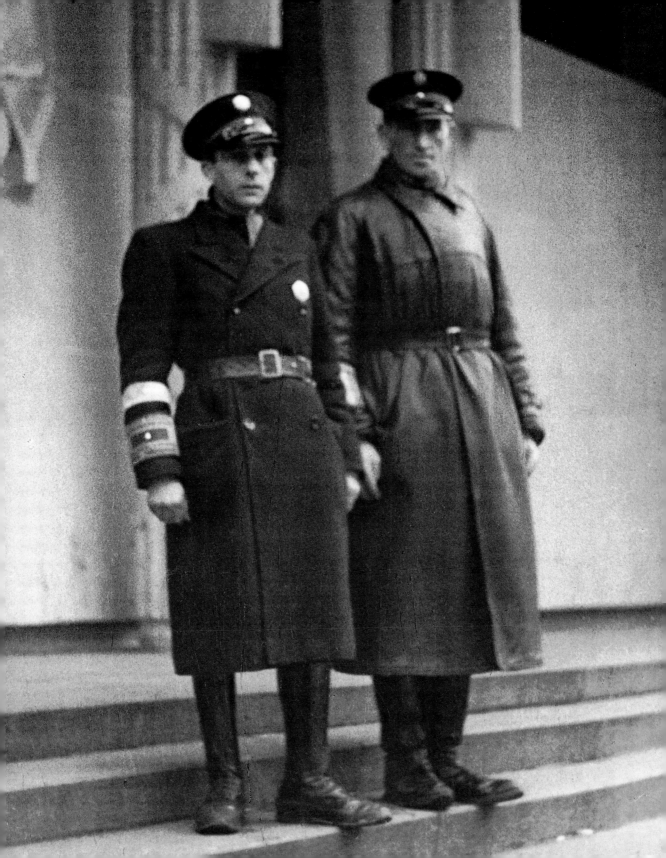

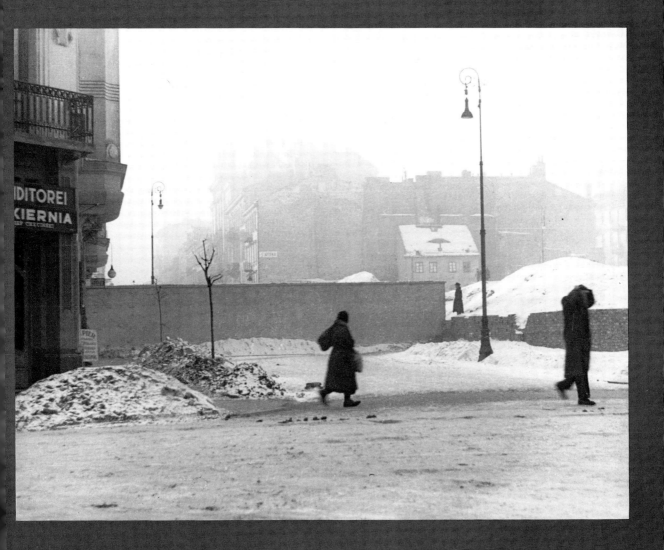

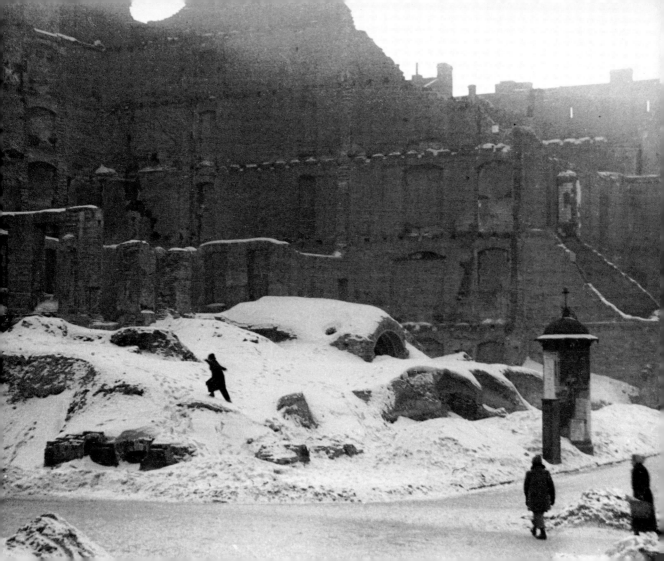

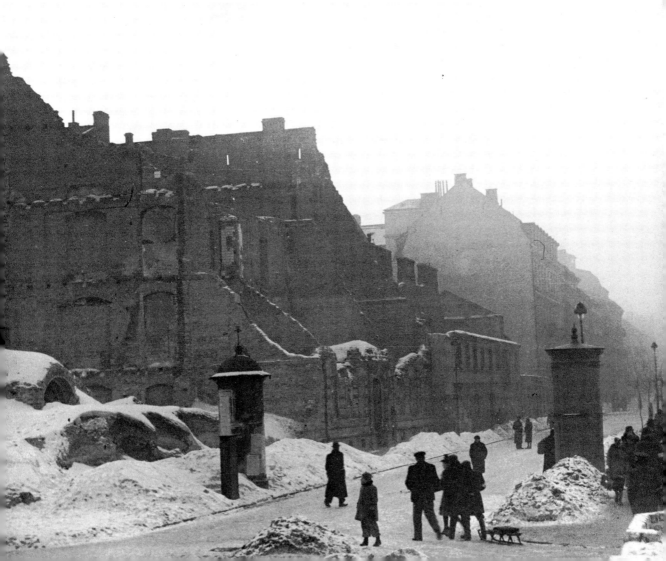

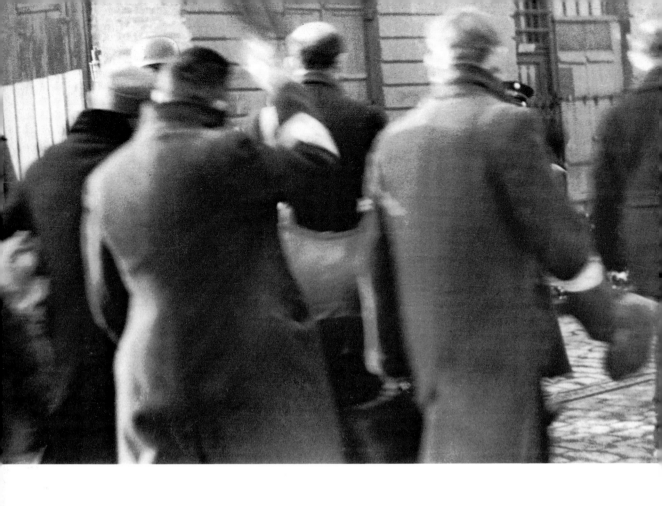

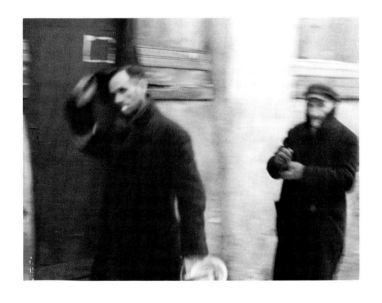

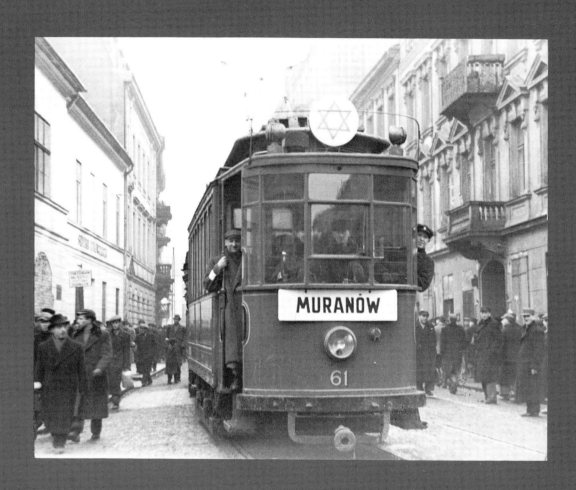

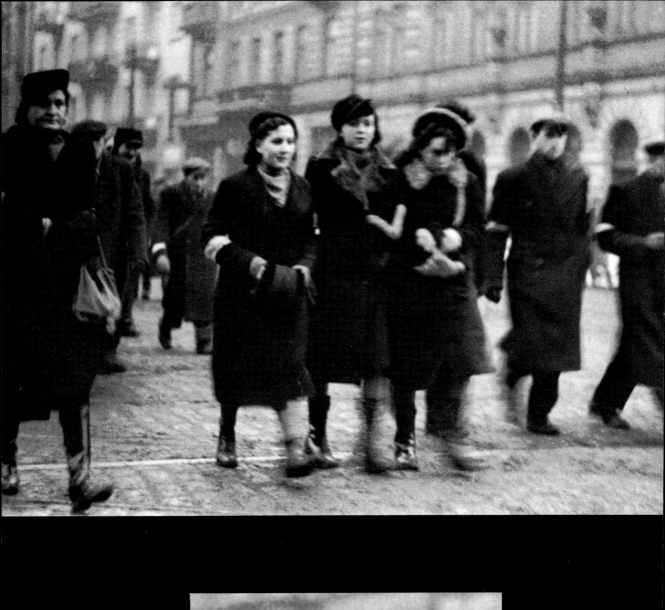

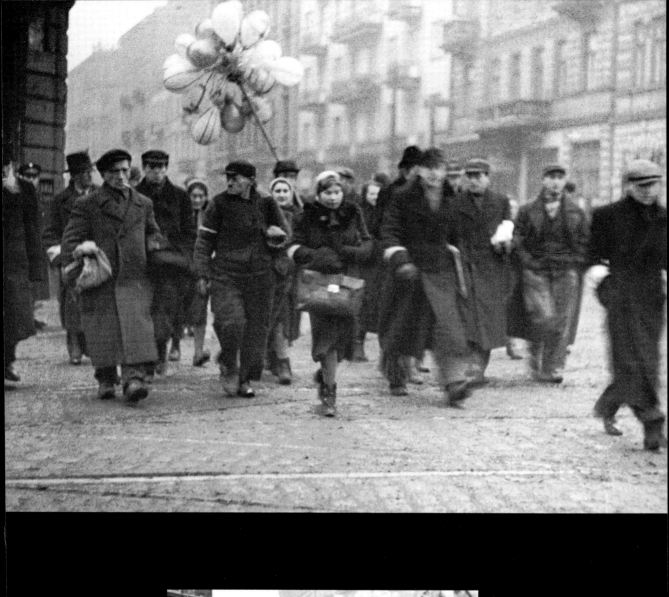

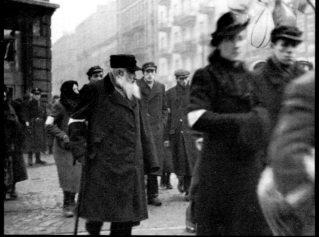

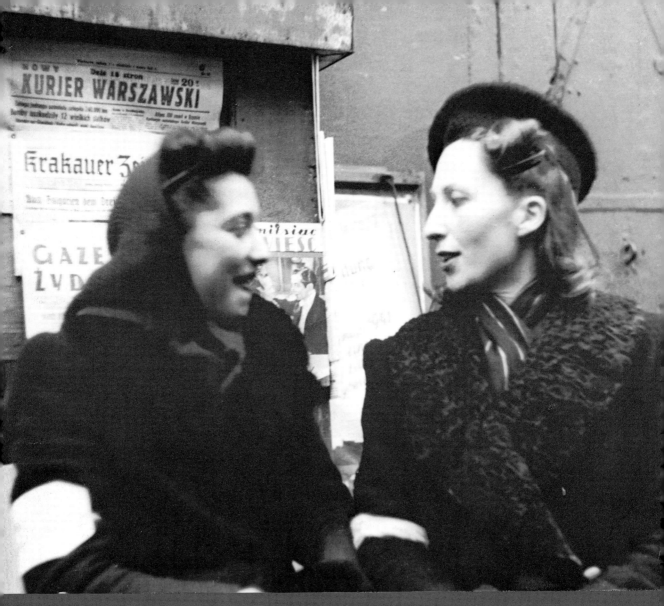

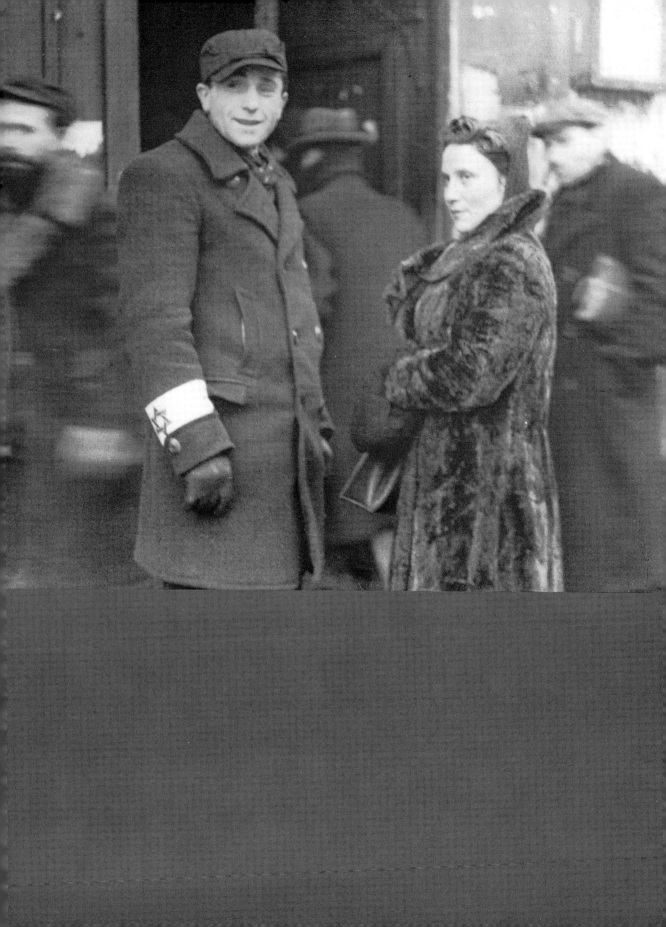

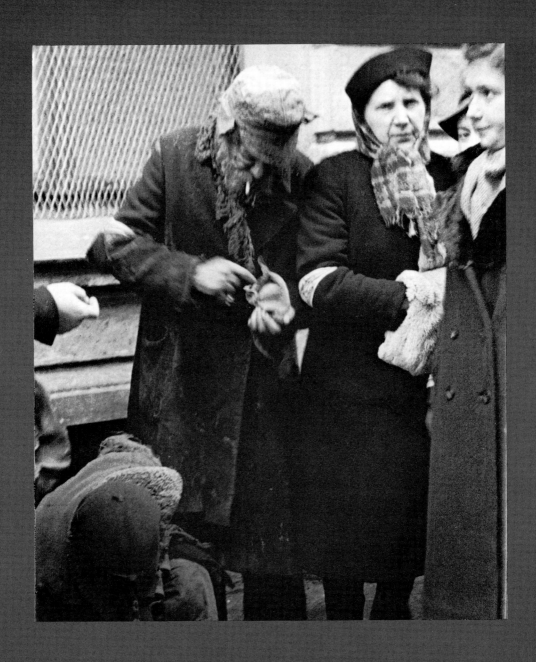

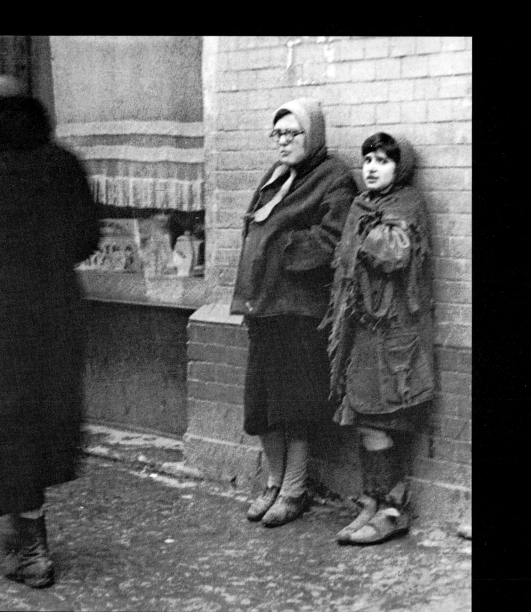

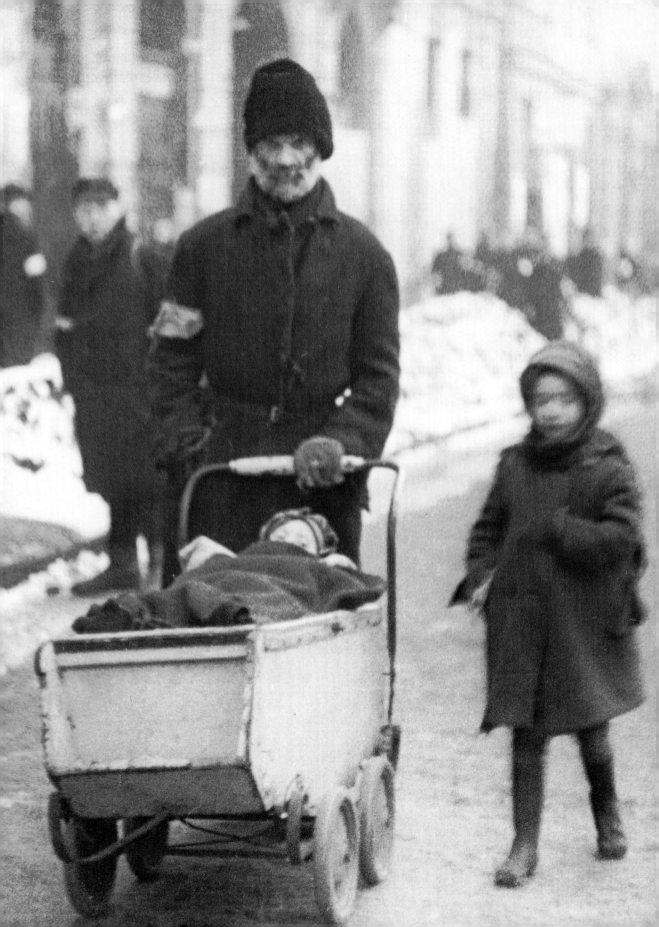

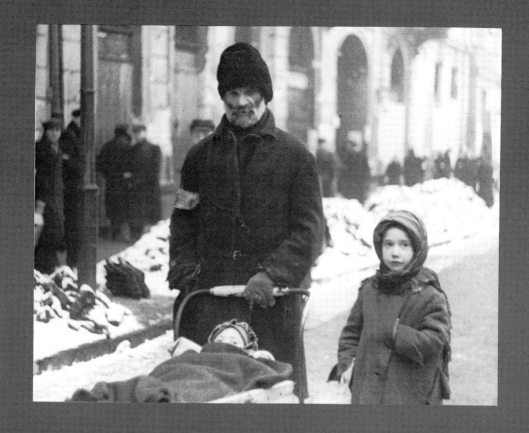

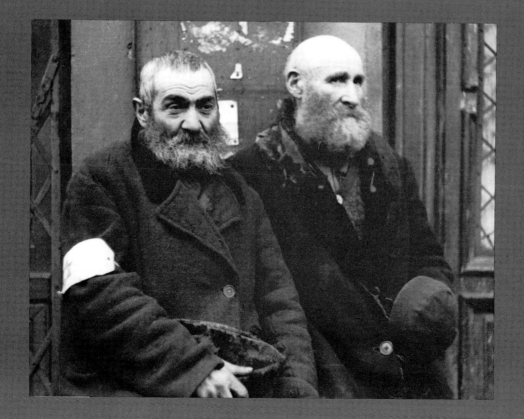

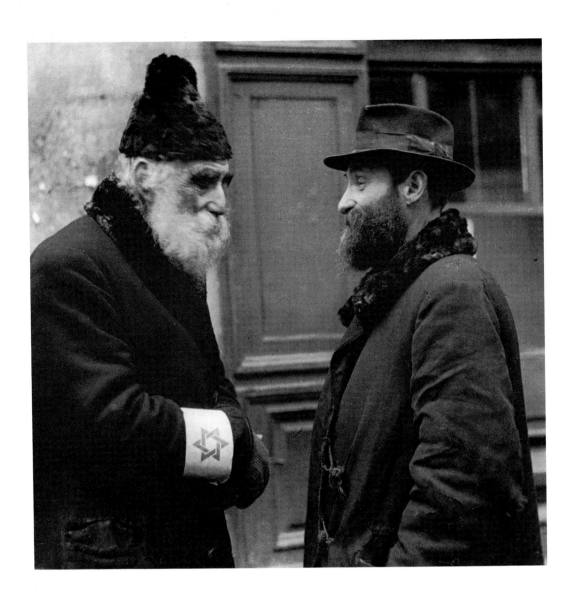

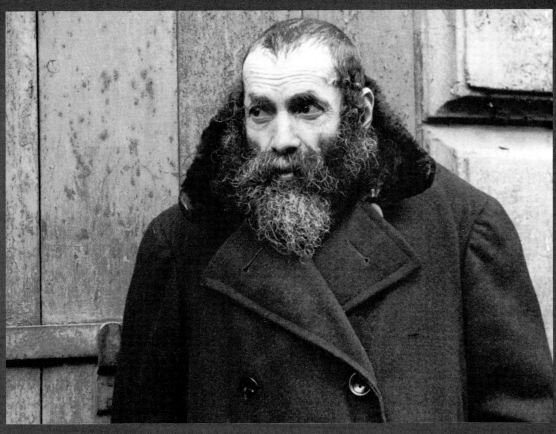

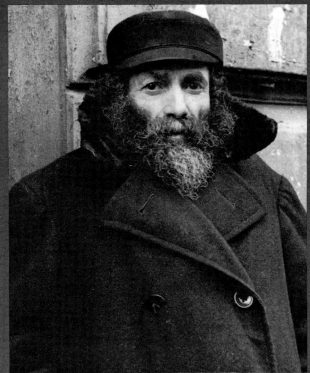

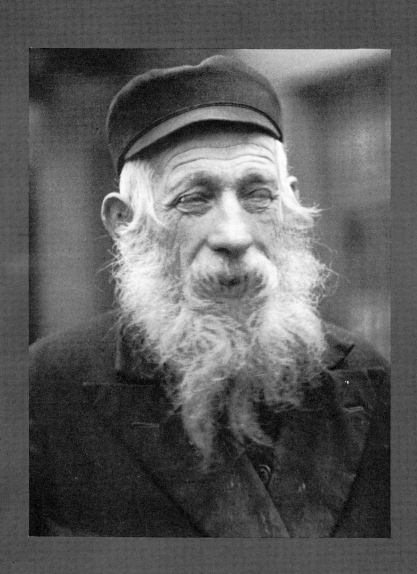

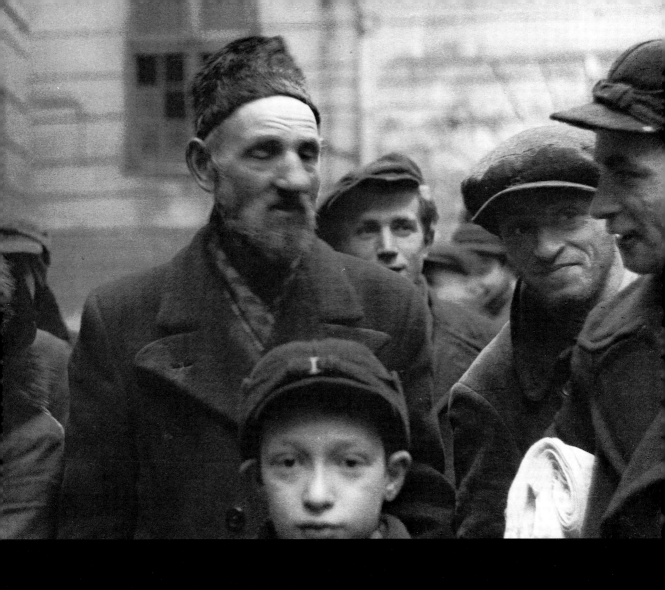

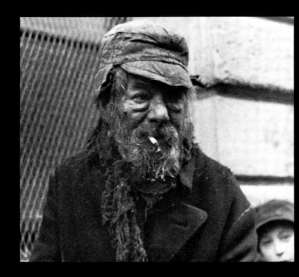

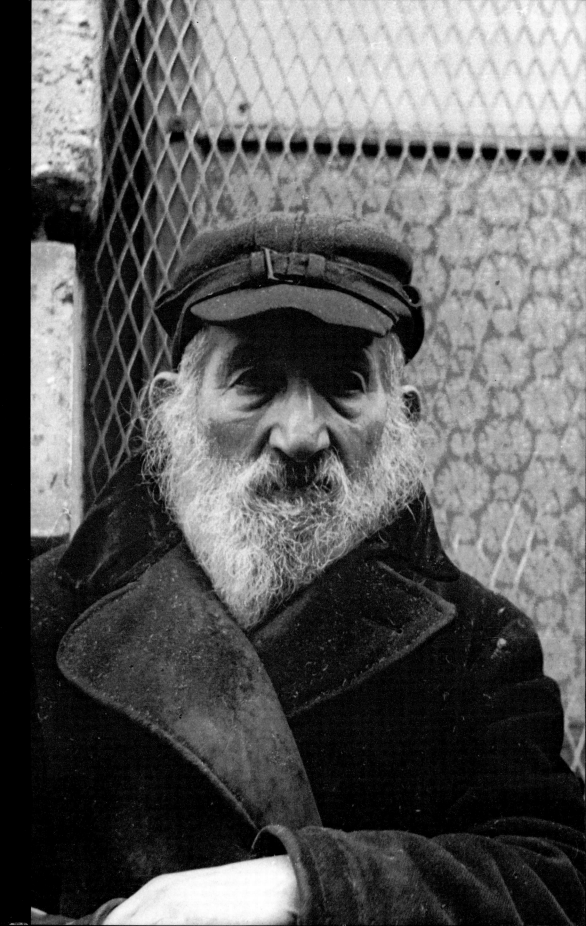

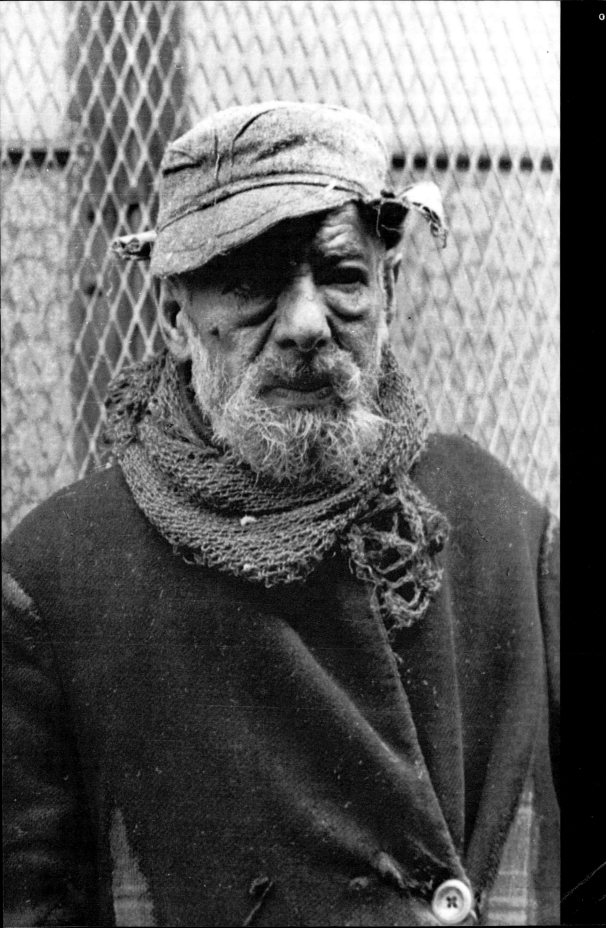

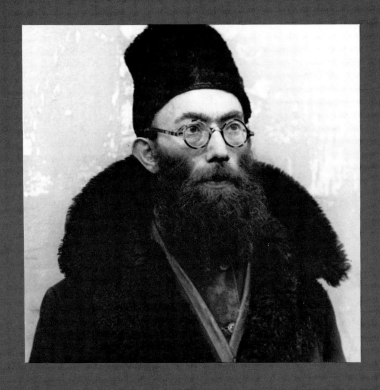

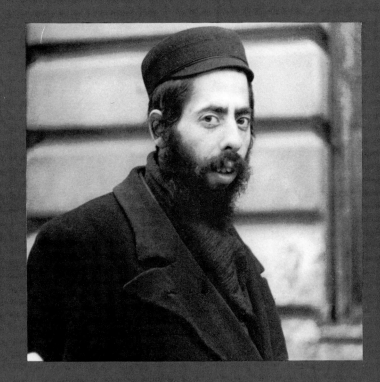

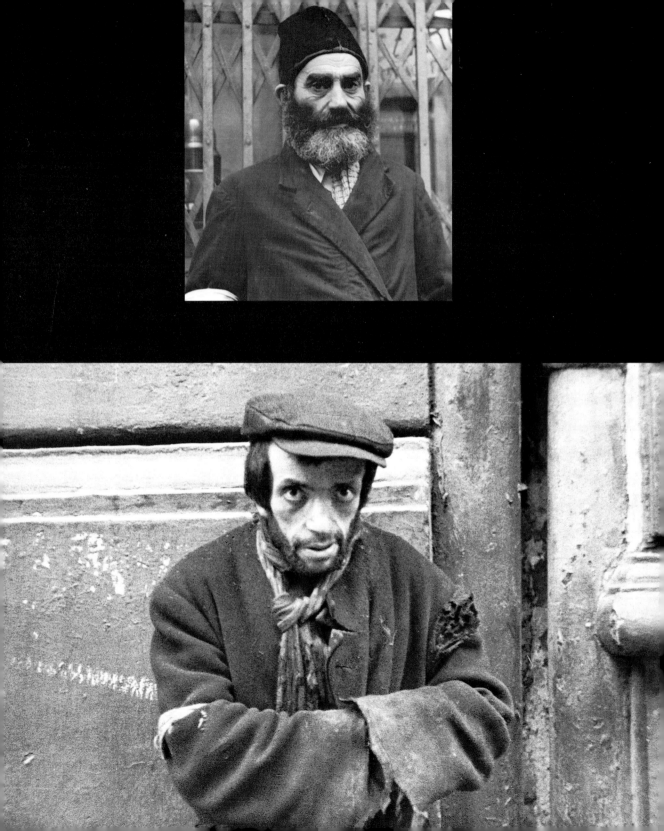

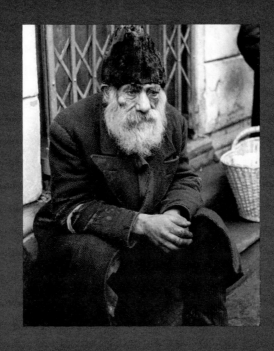

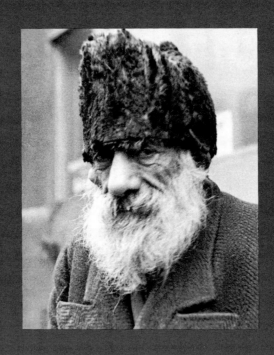

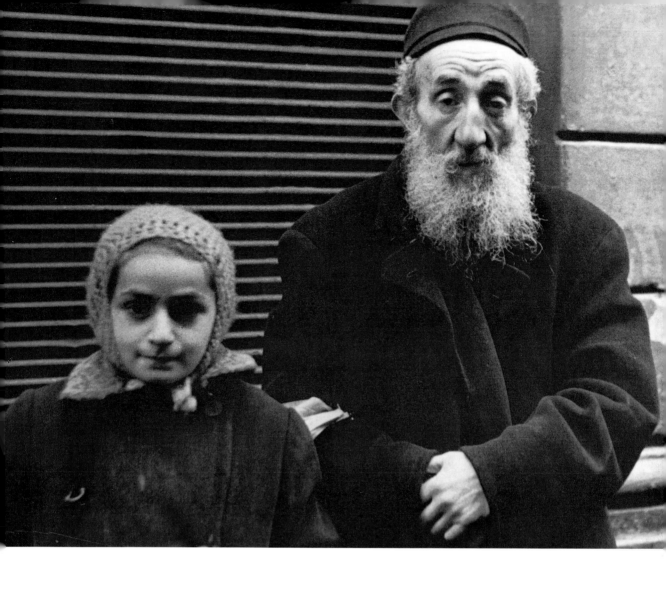

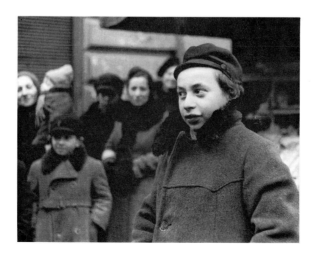

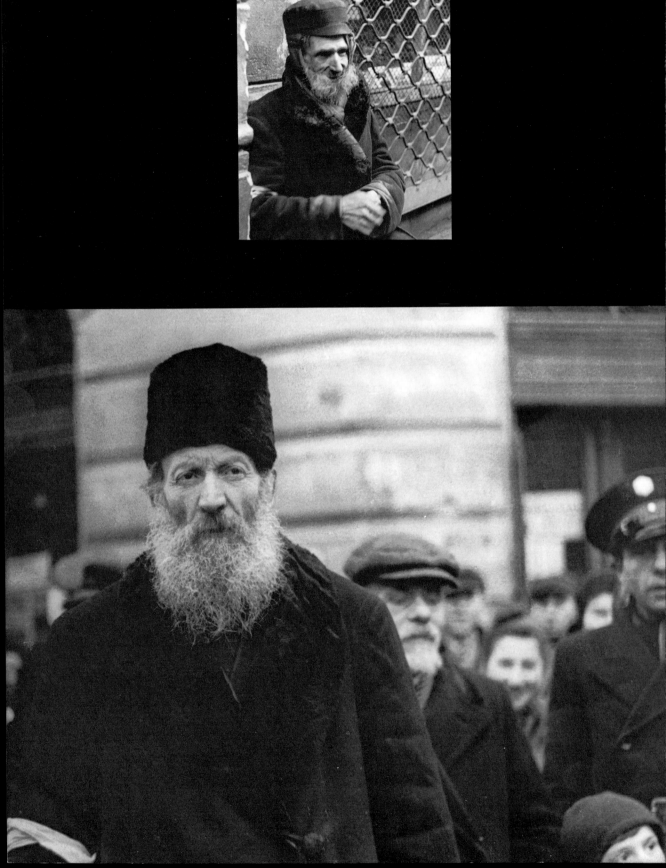

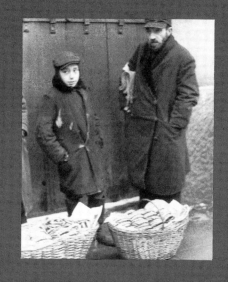

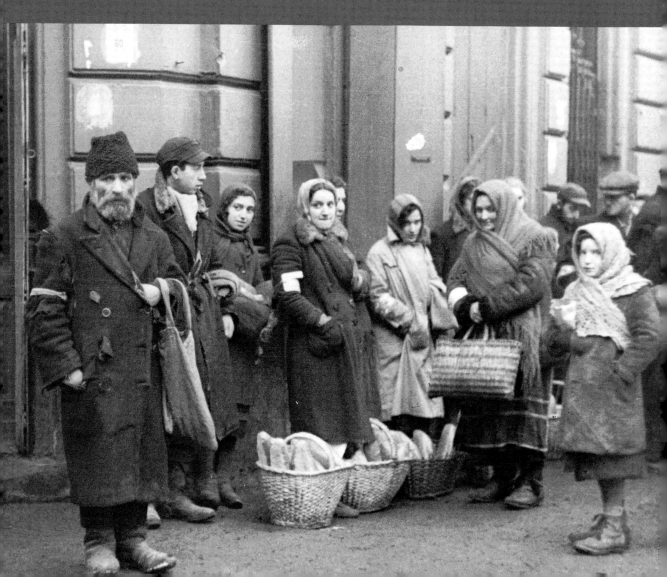

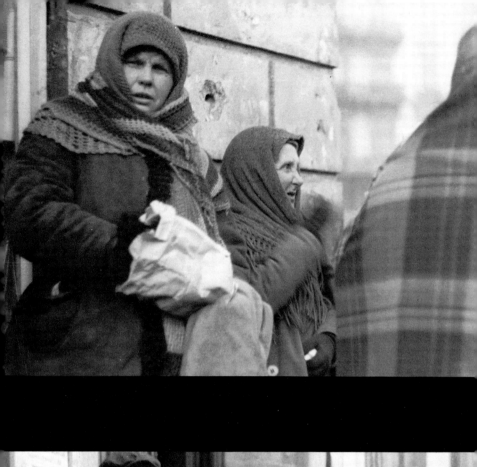
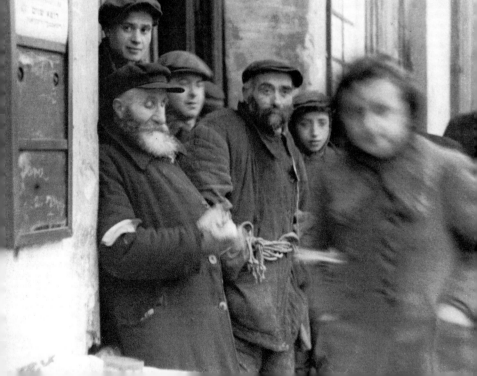

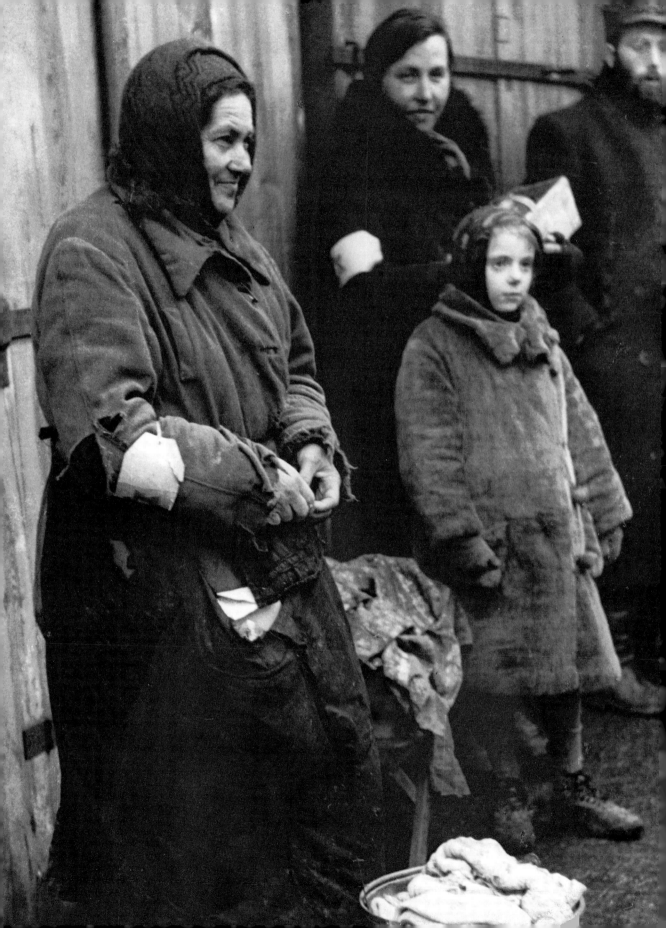

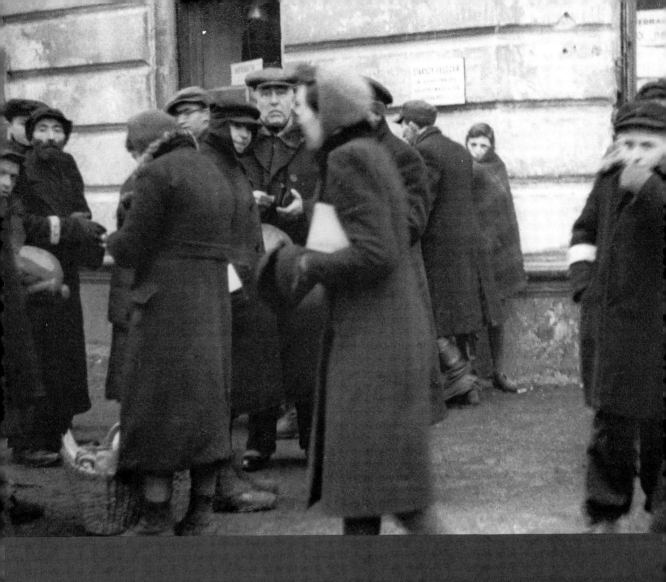

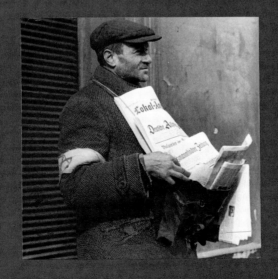

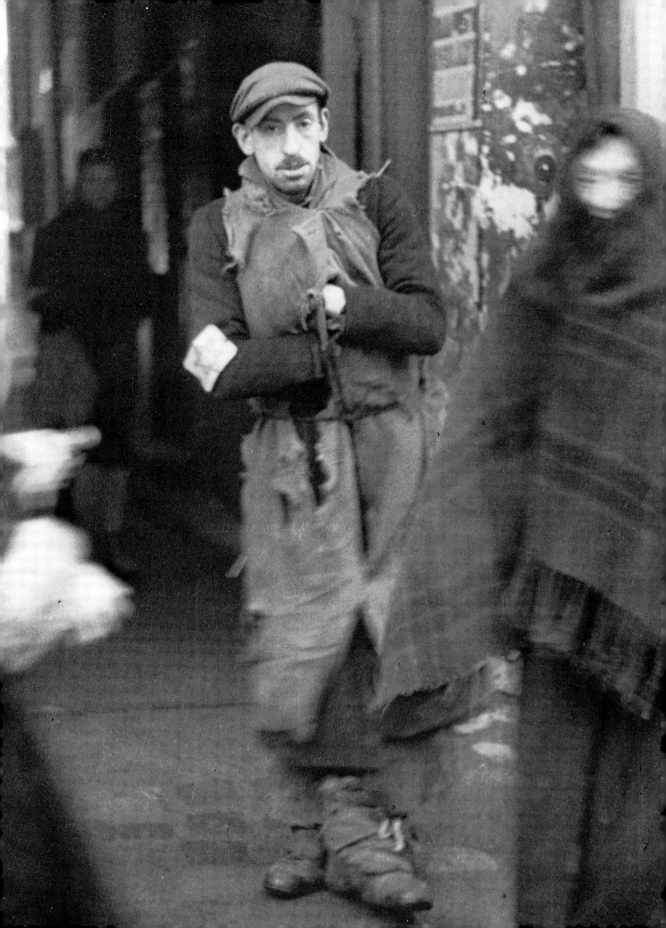

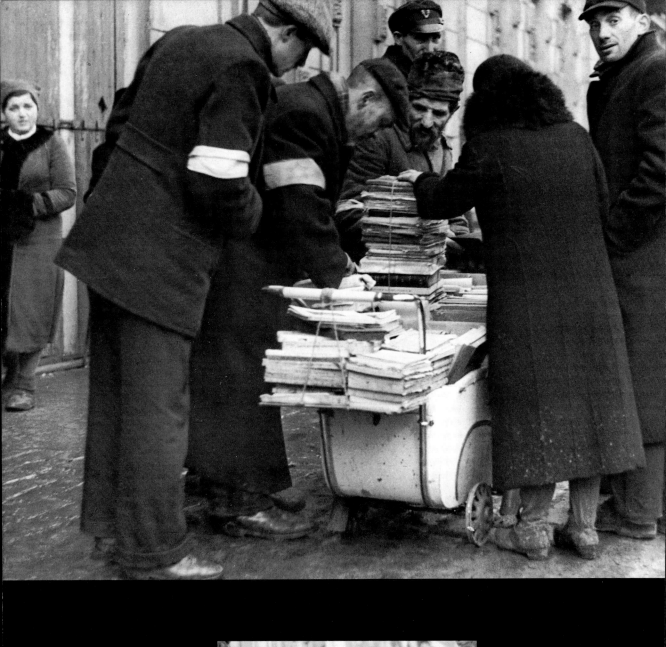

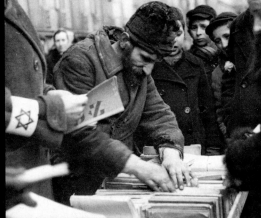

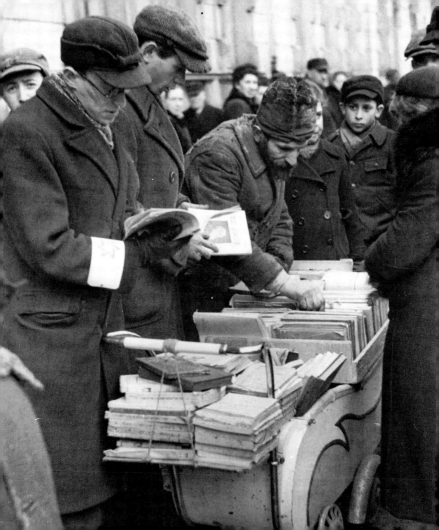

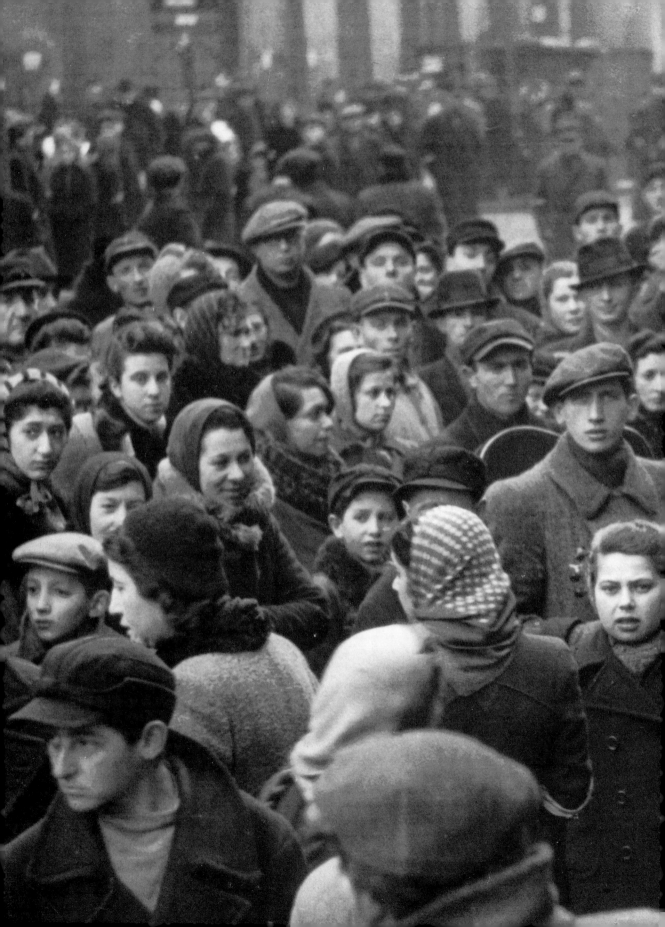

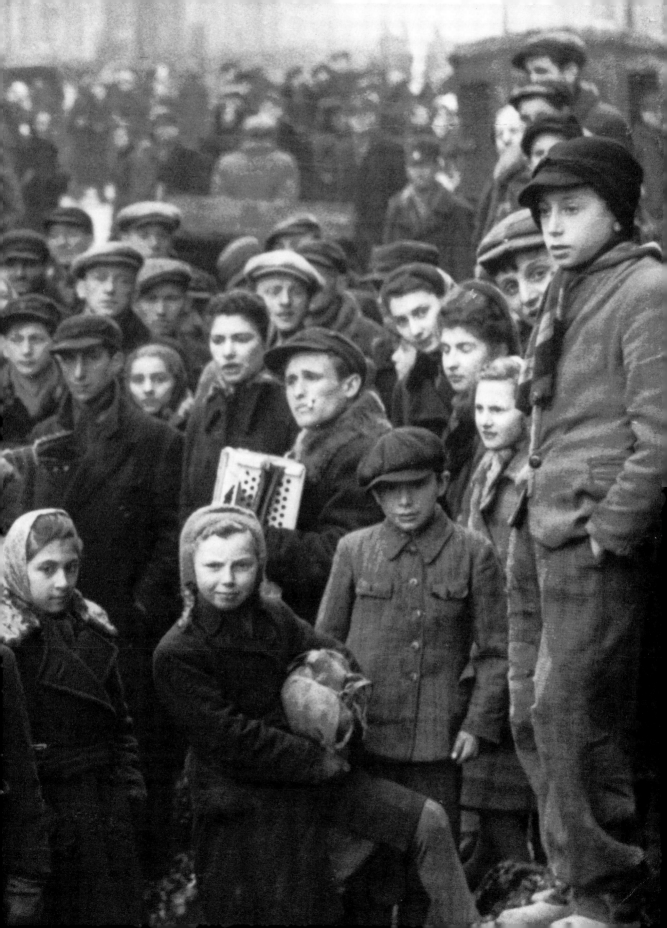

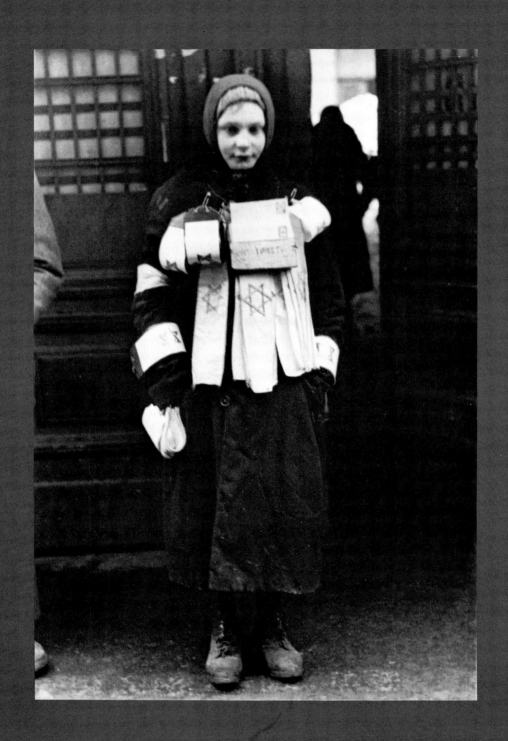

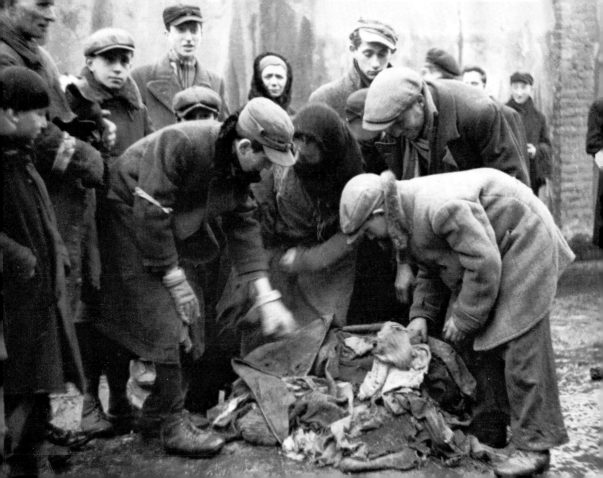

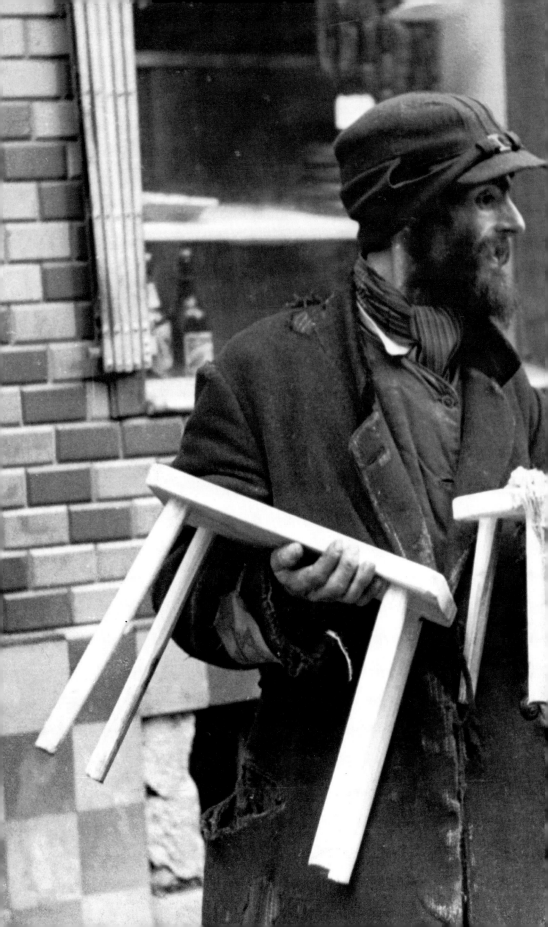

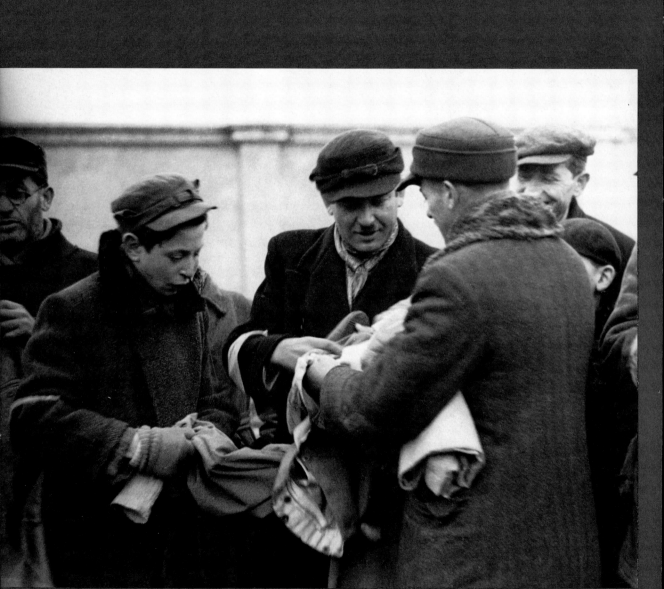

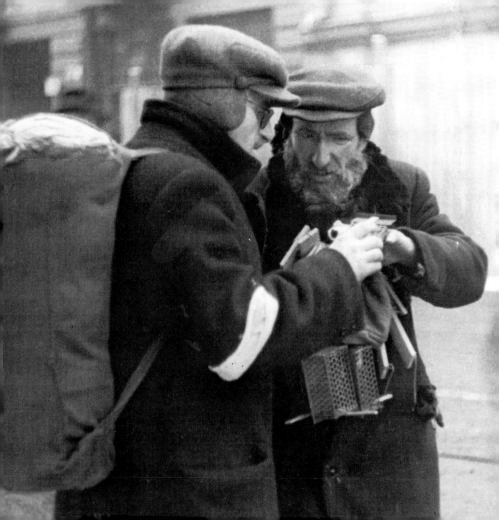

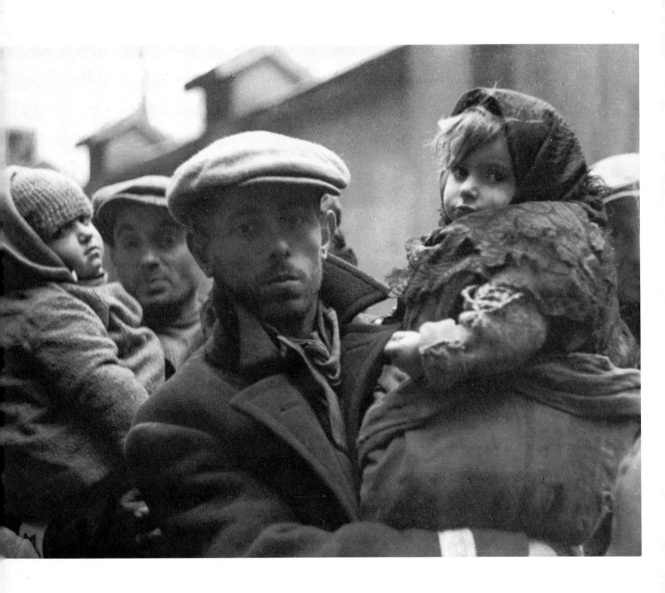

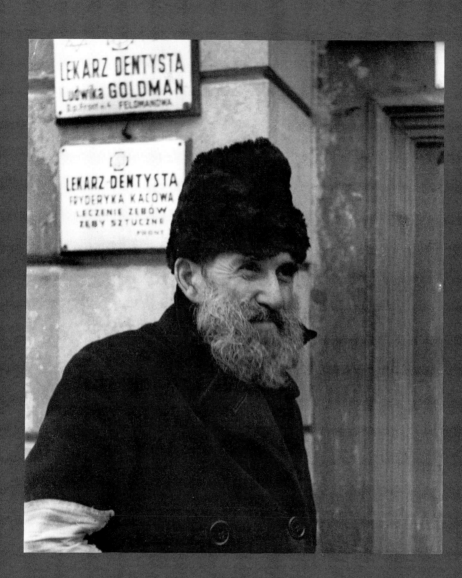

Teatr "ELDORADO" Dzielna 1.

DZIŚ i CODZIENNIE o godz. 5 45
w SOBOTY o godz. 3 po cenach zniżonych 5 45

DUS
DORFS MEJDŁ"

KOMEDJA w 2 ch AKTACH J. Majzelsa. MUZYKA A. Somera
REŻYSERJA : K. Cymbalist. DEKORACJE A. Liberman. DYRYGENT A. Wolsztejn

NA CZELE ZESPOŁU ULUBIEŃCY PUBLICZNOŚCI

REGINA CUKIER	ABRAM KURC
MAX BRYN	SYMCHA ROZEN
DAWID BIRNBAUM	POLA ROSEN
KARL CYMBALIST	EWA SZTOKFEDER
FELA GARBARZ	R. MARSAŁOW
JAKÓB GRYNSZPAN	S. SZEFTEL

KASA TEATRU CZYNNA CODZIENNIE od godz. 2
w SOBOTY i NIEDZIELE od godz. 12

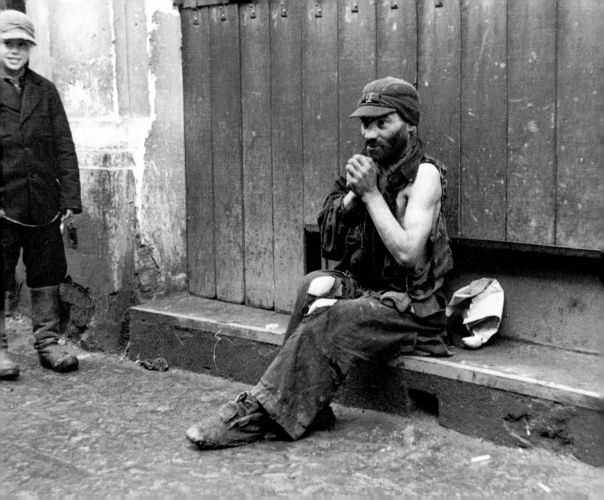

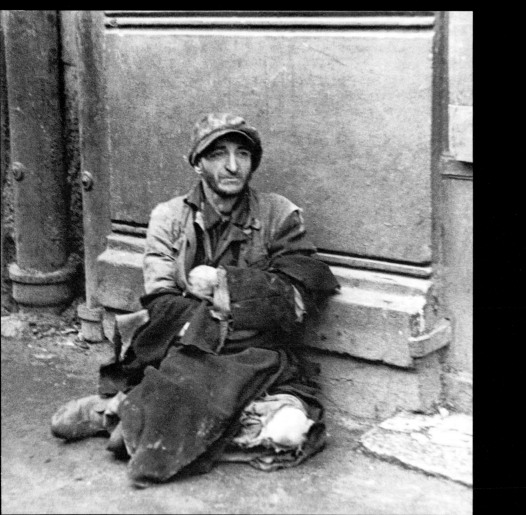

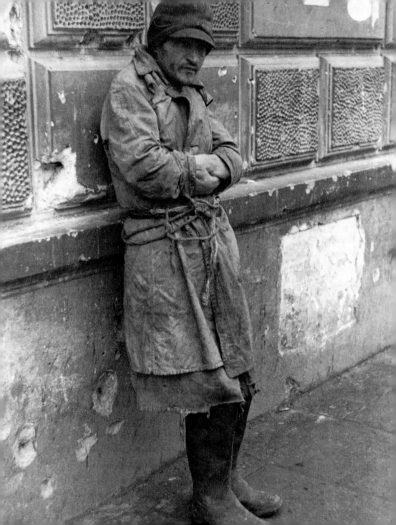

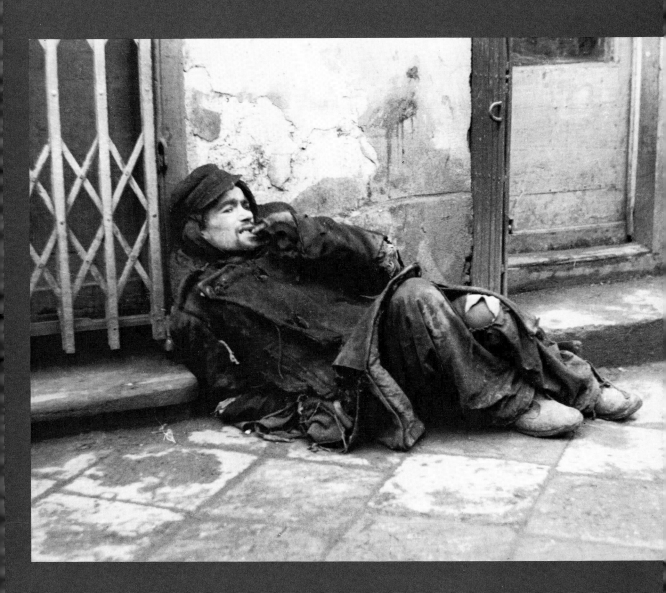

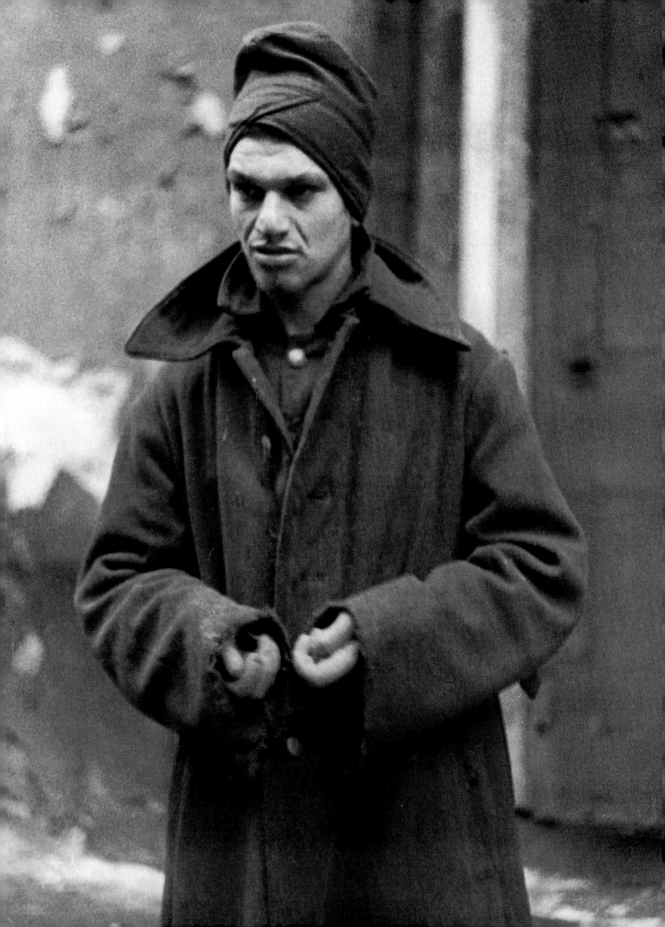

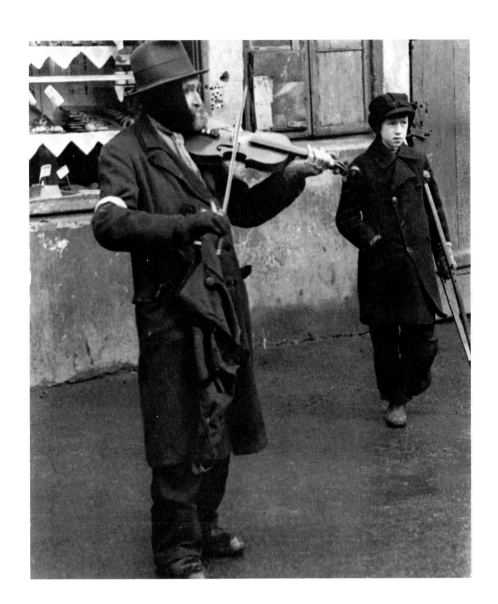

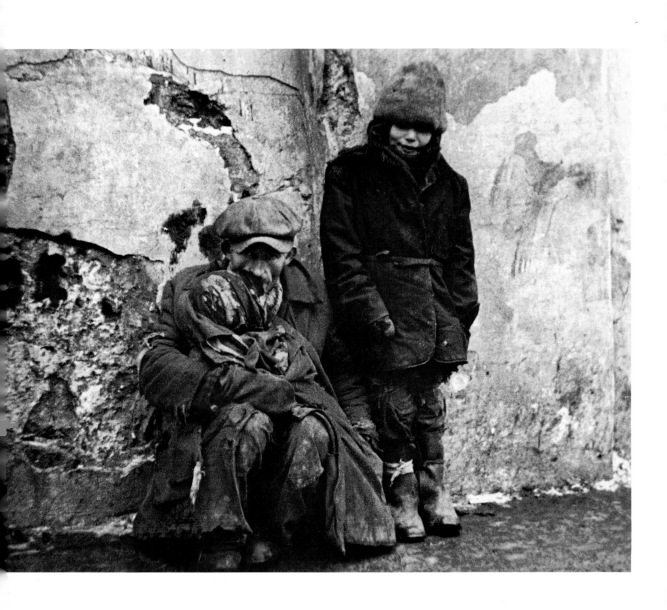

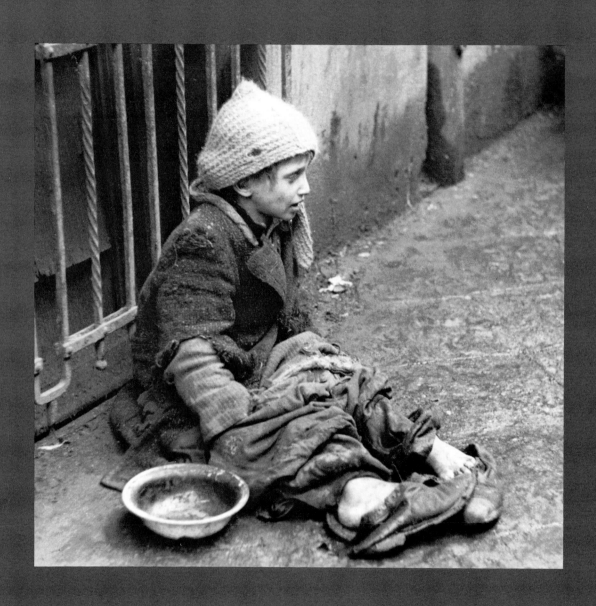

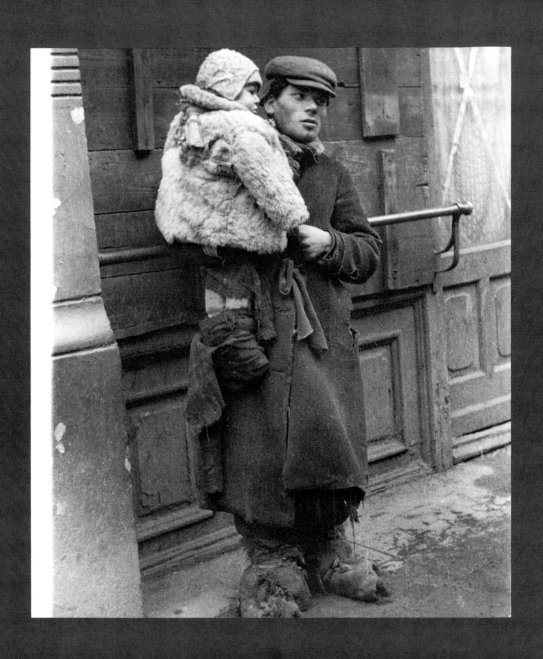

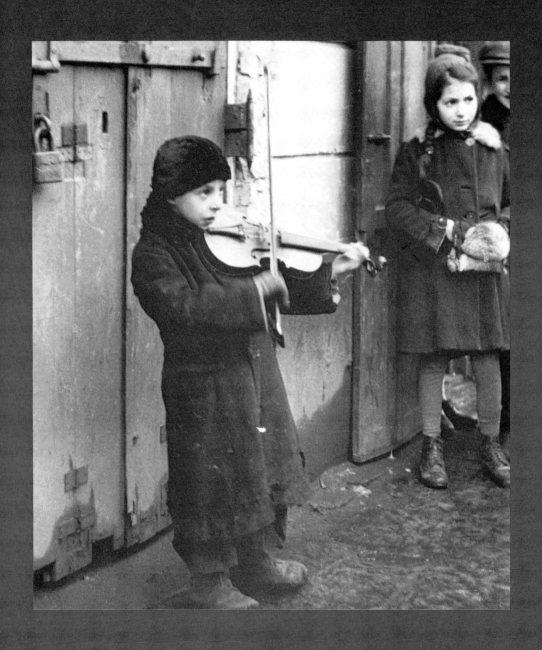

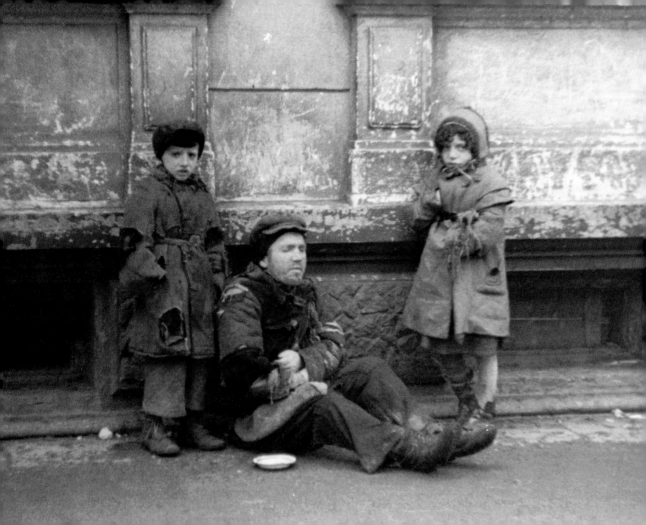

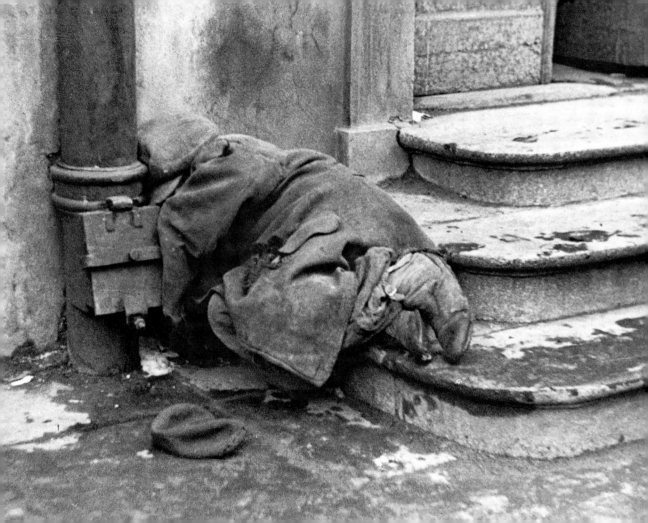

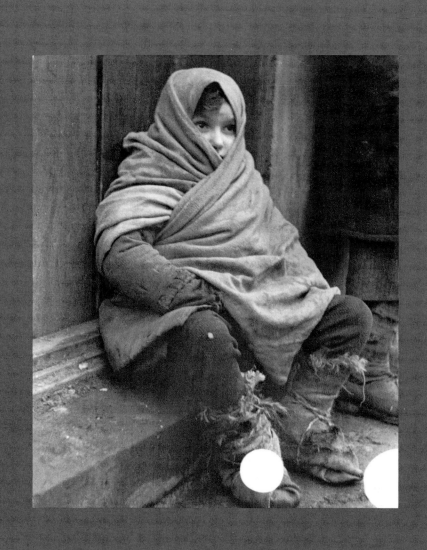

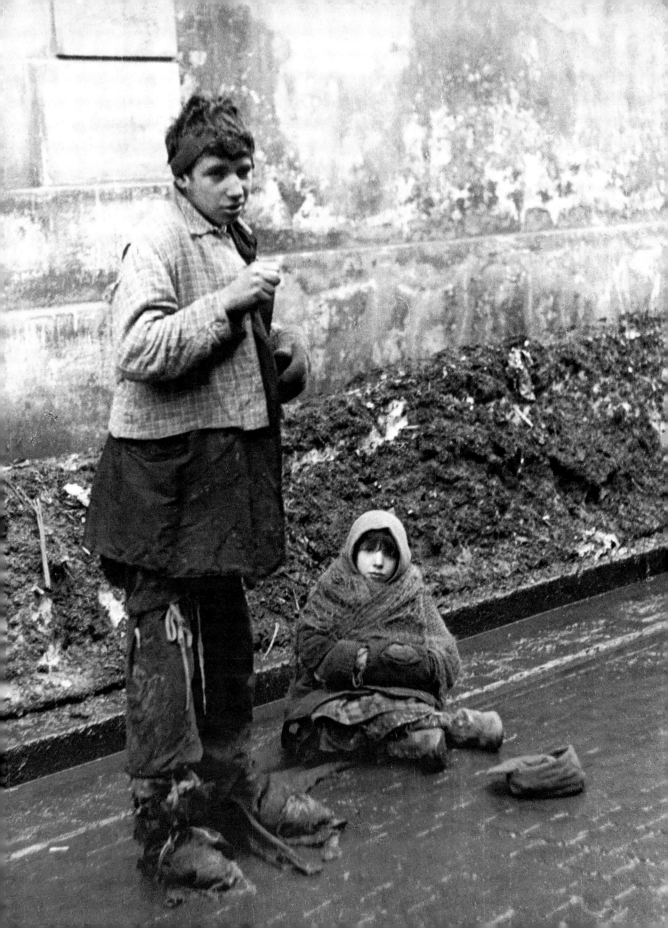

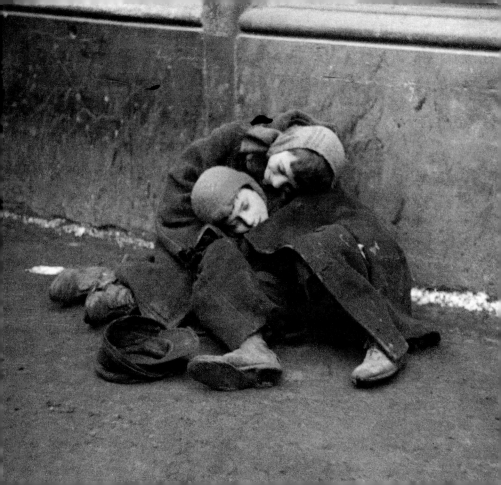

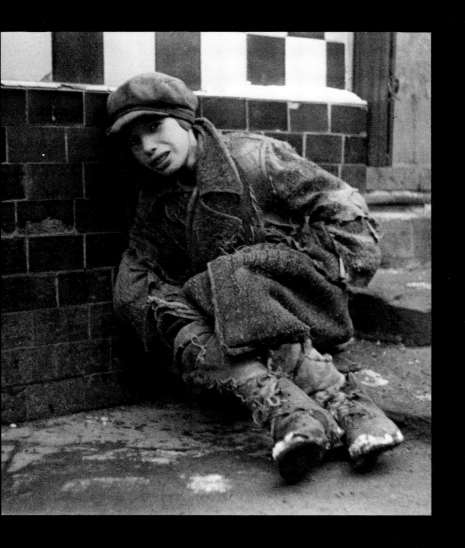

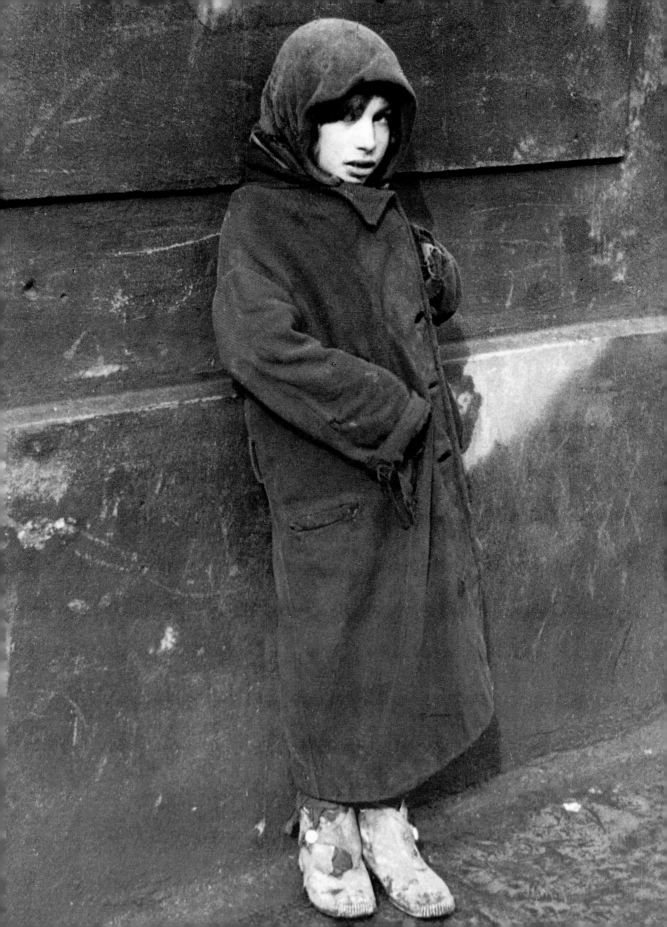

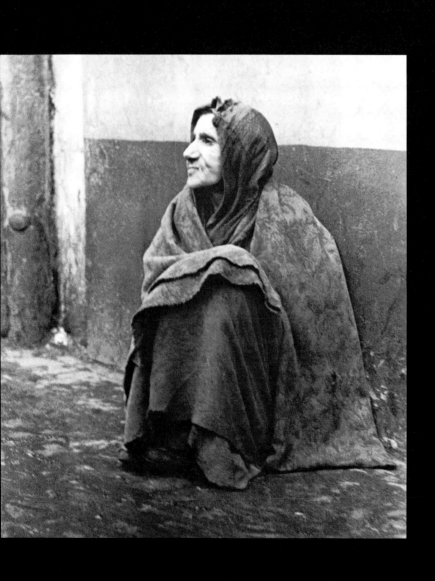

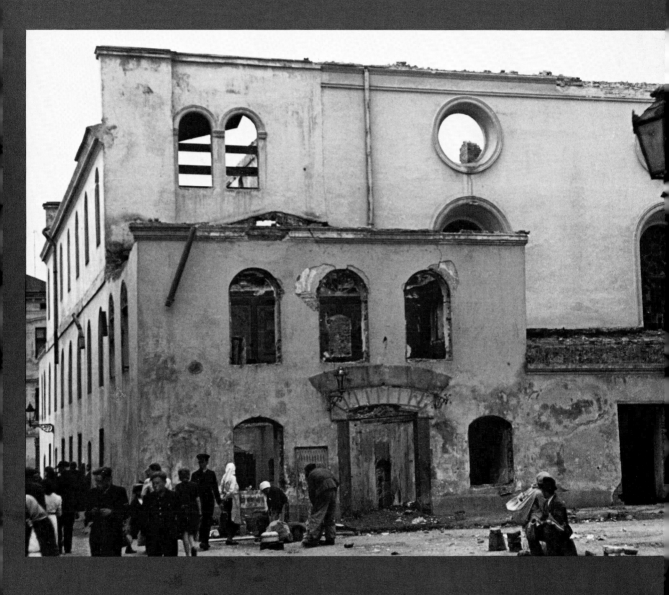

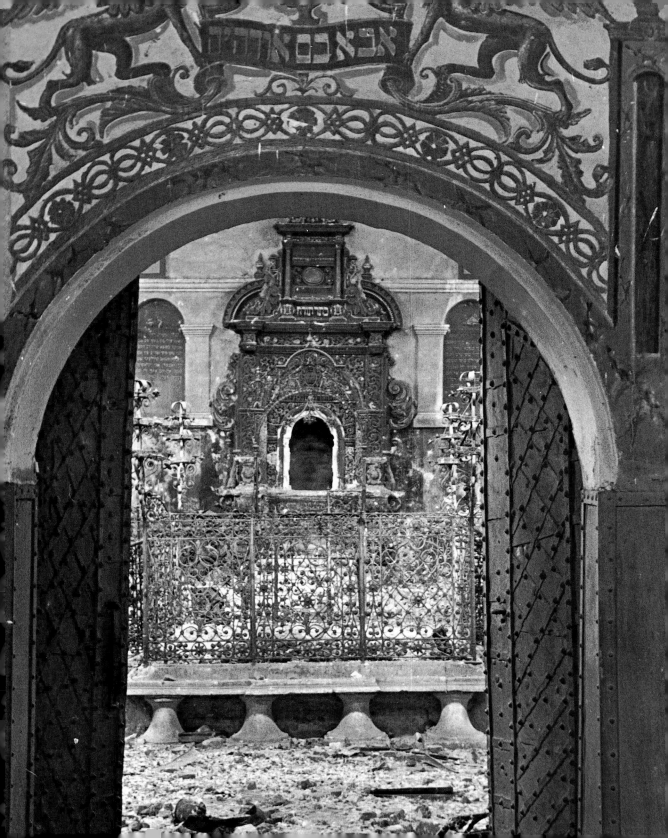

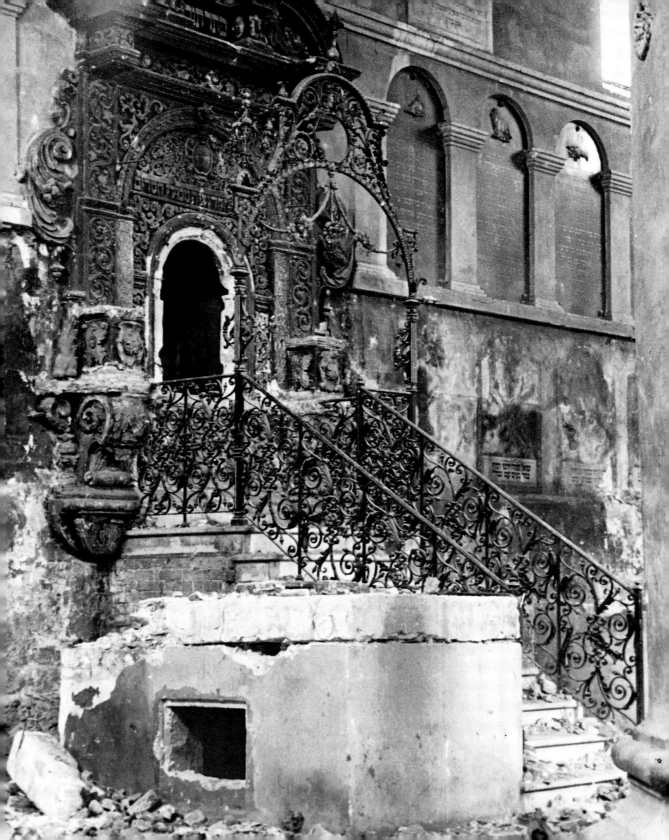

The Ghetto destroyed 20 Nov 1944

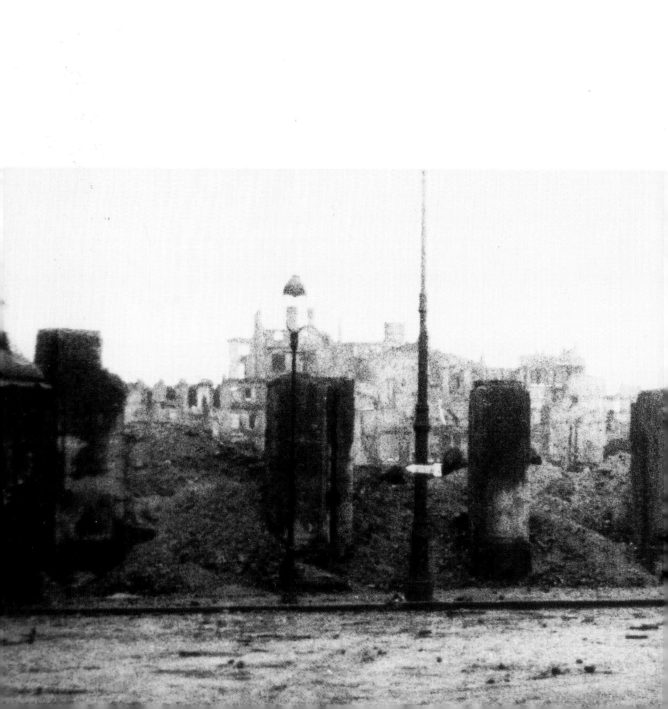

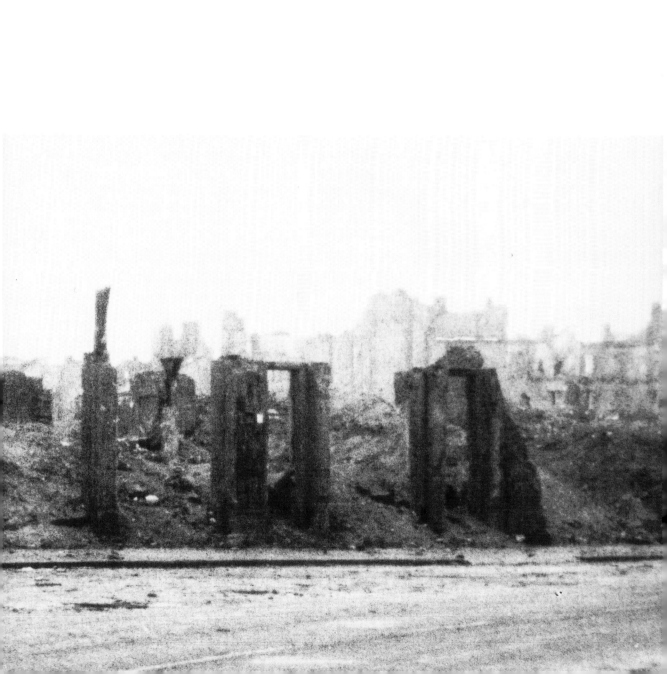